POSTCARD HISTORY SERIES

Athens

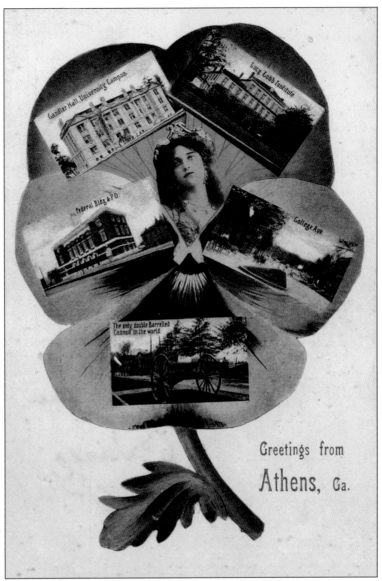

Multi-view postcards showing miniature pictures of local scenes were often used to promote a town's most popular attractions. This postcard depicting some well-known Athens scenes was made in the form of a pansy. The scenes shown here are Candler Hall on the University of Georgia (UGA) campus, Lucy Cobb Institute, the Federal Building, a view down College Avenue, and Athens's famous double-barreled cannon. (Author's collection.)

ON THE FRONT COVER: Bird's-eye views on early postcards were commonly used to show large areas of a town. These views were made from the tallest structure in town, such as a hotel, city hall, courthouse, or church steeple. (Author's collection.)

ON THE BACK COVER: The Athens Cycle Company on Lumpkin Street sold Iver Johnson and Elco bicycles and was the local agent for Indian motorcycles. (Author's collection.)

POSTCARD HISTORY SERIES

Athens

Emily Jean Doster and Gary L. Doster

ARCADIA
PUBLISHING

Published by Arcadia Publishing
Charleston, South Carolina

Printed in the United States of America

Library of Congress Control Number: 2011925248

For all general information contact Arcadia Publishing at:
Telephone 843-853-2070
Fax 843-853-0044
E-mail sales@arcadiapublishing.com
For customer service and orders:
Toll-Free 1-888-313-2665

Visit us on the Internet at www.arcadiapublishing.com

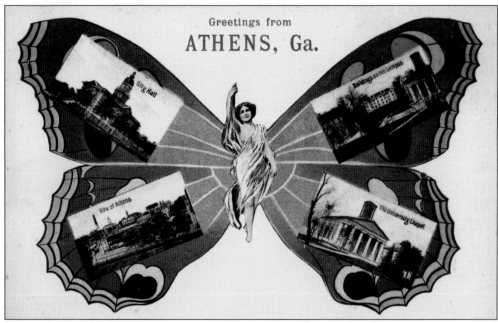

This beautiful multi-view postcard was made in the form of a butterfly. The use of a bare-breasted lady in the center was quite acceptable at the time as a symbol of motherhood. The miniature images of Athens on the butterfly's wings are city hall, buildings on the UGA campus, a view of Athens from the UGA campus, and the UGA Chapel. (Author's collection.)

CONTENTS

ACKNOWLEDGMENTS

Special thanks are due to Ed Jackson for making the professional-quality scans of the postcards used in the book. When our old computer was being replaced with a new one and we were without scanning abilities, Ed stepped up and bailed us out, and we are grateful for his help. High praise and thanks also are offered to George and Charlotte Marshall for their editorial skills. Simply said, no one does it better, and we are fortunate to count them among our friends who will come to our aid when needed.

We also are indebted to a number of people for selling, trading, giving, or lending us the postcards that were used. We thank others for providing information that helped identify some of the people or scenes. We appreciate everyone's contributions and are grateful for their assistance.

We would like to thank: Carl Anderson, Patsy and Wayne Arnold, Dale Autry, Juanita Autry, Joe Ballentine, Bob Basford, Steve and Eleanor Blackmon, the late John Fuller, Frank Howard, Jimmy Hubert, Jack Leach, the late Ernest Malcom, Eve Bondurant Mayes, Charlie McCoy, Patrick Mizelle, Charles Oldham, Edwin Oldham, the late Gordon Sanford, Lewis Shropshire, Bryson Tanner, and the late Susan Frances Barrow Tate.

Unless otherwise noted, all images are from the postcard collection of Gary L. Doster.

INTRODUCTION

"Of making many books there is no end" (*Ecclesiastes* 12:12). So said the preacher in a passage not usually regarded as prophetic, but that could easily apply to modern-day Athens. Perhaps the beginning of the city of Athens has something to do with the interest Athenians today have in the heritage of their community. Of the four places in Georgia established as a place to put a college (the others being Midway, Oxford, and Penfield), Athens is unique in being the only one to develop into a sizable town.

Several of the earlier books about Athens have many pictures: James Reap's *Athens: a Pictorial History*, Nash Boney's *A Pictorial History of the University of Georgia*, Frances Taliaferro Thomas's *A Portrait of Historic Athens*, Conoly and Al Hester's *Athens, Georgia: Celebrating 200 Years at the Millennium*, and Gary Doster's *A Post Card History of Athens, Georgia.* To this array we now add this book, which emphasizes the pictorial more than the others with enough text to give the historical background of the pictures. More than 30 of these images have never before been published.

These pictures are divided into several categories. Scenes from the University of Georgia campus are featured prominently because the university has always been an integral part of Athens—indeed, the reason for the town's existence. The histories of town and gown have run a somewhat parallel course. Another section that would not be found in books about other towns is a collection of scenes from the US Navy Pre-Flight School, which occupied much of the campus during World War II. Other sections that would be featured in similar books about other towns are downtown Athens, schools and churches, private residences, business and industry, and bridges, trains, and aeroplanes.

The images in this book came into existence as picture postcards. Many of them are more than 100 years old, and they truly are historical treasures. Most of these wonderful old postcards were produced and have survived for 100-plus years because of postcard collectors. Serious postcard collecting began in Europe in the 1890s and rapidly spread to other countries, quickly becoming one of the most popular hobbies in the world. Literally millions of collectors were involved. By 1909, the hobby became so popular in the United States that one national postcard collectors club based in Philadelphia had 10,000 members. The hobby died almost as quickly as it had been born when the world was swept up in the turmoil brought on by World War I. First, the seriousness of the war diverted the attention of everyone to more serious matters, plus many of the prettier high-quality postcards had been produced in Germany, and that option was no longer available. After the war ended, widespread use of the automobile and telephone preempted the need for postcards as an inexpensive, quick, and easy form of communication.

Early collectors bought and traded postcards until interest in the hobby subsided, then preserved the cards in albums or stored them away in boxes until they were discovered by modern enthusiasts who recognized and appreciated their beauty and historical value. There has been considerable resurgence in the interest in postcard collecting in recent times, primarily for their unique status as often being the only surviving image of some scene long since gone. Professional historians, as well as collectors, have come to appreciate more and more the importance and value of old postcards, and many libraries and museums have built substantial collections. In recent years, postcards have been used to illustrate thousands of books, and our lives have been enriched by having them available.

During the zenith of postcard collecting in this country from about 1903 until the outbreak of World War I, many early scenes that were never photographed for any other reason were depicted on postcards. Fortunately, like the rest of the country, Athenians were caught up in the postcard-collecting craze, and many scenes appeared on postcards that were not pictured elsewhere.

Now, many old homes, railroad depots, storefronts, courthouses, businesses, and numerous other structures and views that were depicted on postcards are gone. These old postcard views are the only photographic records of their existence.

Especially valuable are the real-photo postcards that usually were produced in small numbers, and often, only one or two copies are still in existence. Plus, most of these real-photo postcard views are of superior quality and afford sharp, clear images that rival even modern photographs.

Commensurate with their historic worth, the monetary value of postcards has grown concomitantly. Many rare cards that could be bought for a dollar or two a few years ago now sell for multiples of previous amounts. Indeed, when two or more serious collectors compete in an auction nowadays, it is not unusual for a rare and desirable card to sell for more than $100. This book makes even high-priced postcard scenes accessible for only a fraction of what would otherwise be the cost.

Athens is an unusual community in several ways. It is a city of contrasts. It is a college town with a vigorous chamber of commerce. The interest in and respect for the past are matched by an enthusiasm for the future. Research discoveries in a world-class university occur in a town determined to preserve whatever is of historical importance.

Although some of our historical properties that could have been preserved were not protected in the past, Athenians have been actively safeguarding and restoring our old treasures since the 1960s. In many cases, the large 19th-century homes would not have survived had they not become the chapter houses of sororities and fraternities. In recent decades, historical properties have been restored and adapted for professional and business offices. Athens is proud of its history and recognizes it as a cultural and economic asset.

Though conscious of its rich history, Athens is a vibrant, progressive city, famous in recent years as one of the leading music venues in the country. Young musicians from throughout the nation flock here, hoping to break into the music scene. Dozens of downtown clubs and bars provide opportunities for young musicians to gain entrance into this magical world. Many world-famous bands got their start here.

It is with pride that we present for your enjoyment this first foray into historical publishing as a result of collaboration by grandfather and granddaughter.

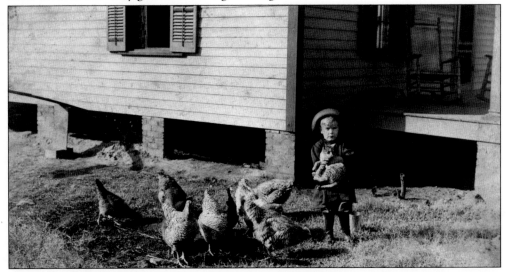

As a child, Gordon Sanford lived in this large frame rental house at 975 Oglethorpe Avenue with his uncle George Raymond Sanford and Raymond's sister Evalyn. Raymond was the head mechanic with the Athens Railway and Electric Company. In this 1913 postcard, four-year-old Gordon is holding the family cat, surrounded by a flock of chickens. This house was demolished in the 1960s, and the Church of Christ was built on the site.

One

DOWNTOWN ATHENS

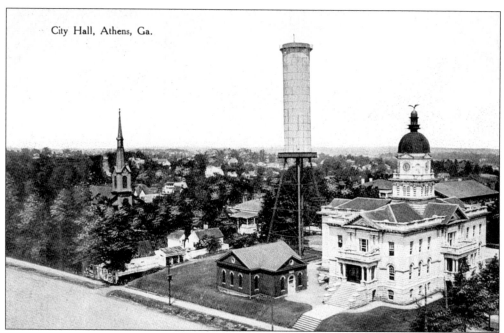

City hall was built on the highest elevation in Athens. A 176,000-gallon water tank was erected behind the building, and a modern brick jail was constructed on the Washington Street side. The location of the water tank on this elevation was key because Athens's water system depended on gravity flow to furnish water to residents.

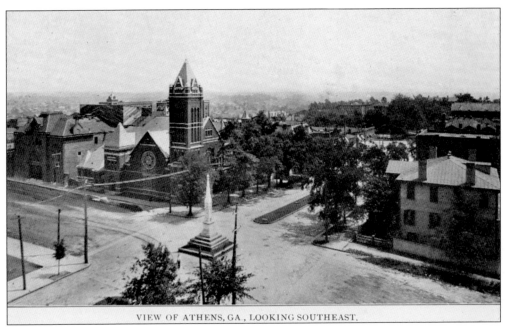

VIEW OF ATHENS, GA., LOOKING SOUTHEAST.

The view from the top of city hall looking down at the intersection of College Avenue and Washington Street around 1907 is very different today. The Confederate Monument was in its original location. The Eustace Speer home, where the parking garage is now located, was demolished about 1920. The Athens Baptist Church building across the street was demolished about 1921, and the Colonial Theater next door was demolished in 1932.

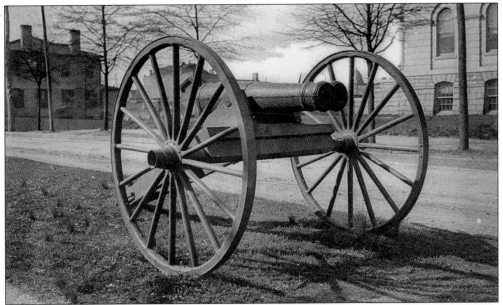

The Athens double-barreled cannon was created by local carpenter John Gilleland during the War Between the States. Gilleland postulated that two cannon balls connected by a chain could be fired simultaneously, and the chain would stretch taut and mow down the enemy like cutting wheat with a scythe. It sounded like a good idea, but it did not work. One ball exited the barrel before the other, broke the chain, and flew out of control.

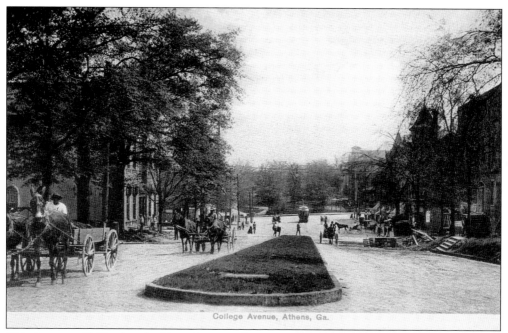

College Avenue, Athens, Ga.

This is a pre-1907 view looking down College Avenue from the base of the Confederate Monument at the intersection of College Avenue and Washington Street. Part of the old 1876 Southern Mutual Building can be seen on the left at the intersection of College Avenue and Clayton Street.

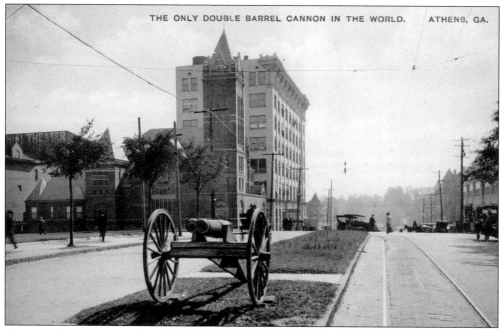

THE ONLY DOUBLE BARREL CANNON IN THE WORLD. ATHENS, GA.

Grassy medians once occupied the middle of College Avenue between Hancock Avenue and Clayton Street. The double-barreled cannon sat on the strip in front of city hall for many years. In this post-1912 view, the Confederate Monument has already been moved to its present location on Broad Street.

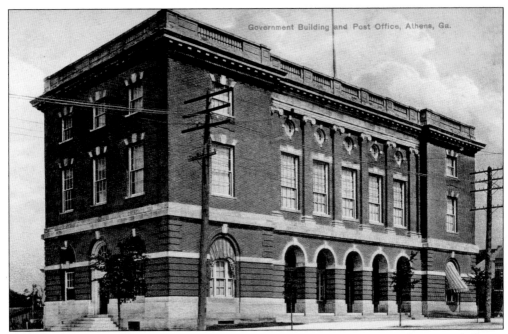

The old Federal Building and US Post Office on College Avenue across from city hall was completed in 1905. Other federal agencies, including the US Department of Agriculture, also occupied space in the building. When the post office was relocated in 1942, the USDA remained and took over the entire building. The building was saved from destruction in the mid-1960s when it was bought by First American Bank and Trust Company.

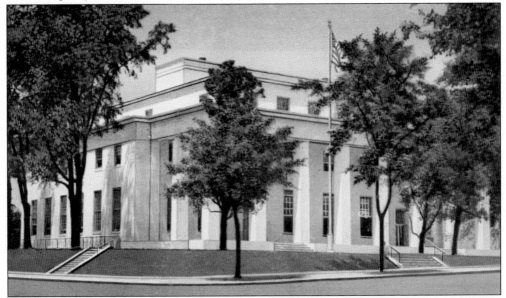

The new Federal Building and US Post Office on the corner of Hancock Avenue and North Lumpkin Street was completed in 1942 to replace the old facility on College Avenue. The design conformed to the architecture of many older homes and buildings in Athens, making it different from any other post office in the country. The present post office was completed on Olympic Drive in the early 1990s, and this building became office space.

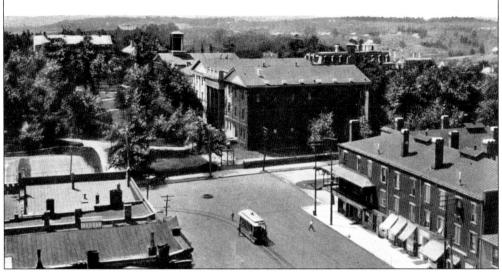

This bird's-eye view of the intersection of Broad Street and College Avenue was captured from the top of the Southern Mutual Building. A streetcar turns in the intersection in front of the old Newton House, a hotel built in the 1850s, where the world-renowned Varsity restaurant served its famous chili dogs from 1932 until its closing in 1978. The hotel was successively named the Cherokee Hotel, the Commercial Hotel, and the Colonial Hotel.

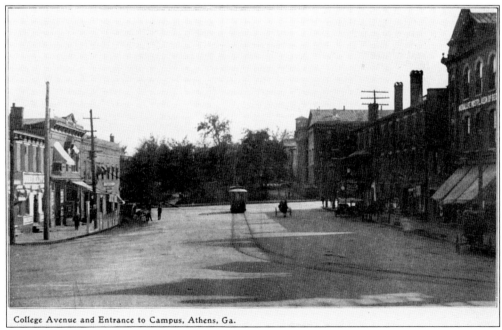

College Avenue and Entrance to Campus, Athens, Ga.

This is a ground-level view of the same intersection, looking toward the campus.

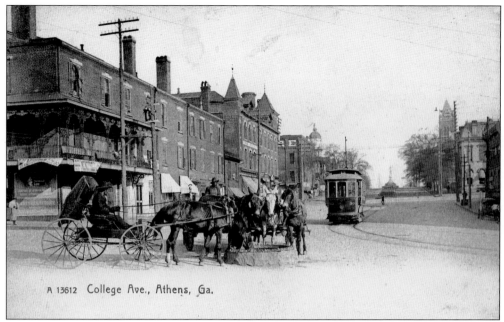

A 13612 College Ave., Athens, Ga.

Looking north up College Avenue from the UGA Arch, one is provided a good view of the stone horse-watering trough in the middle of the intersection and the ornate ironwork on the second story of the Newton House. This view was made about 1905, and there are no automobiles in sight. The 1876 Southern Mutual Building can be seen on the corner of College Avenue and Clayton Street.

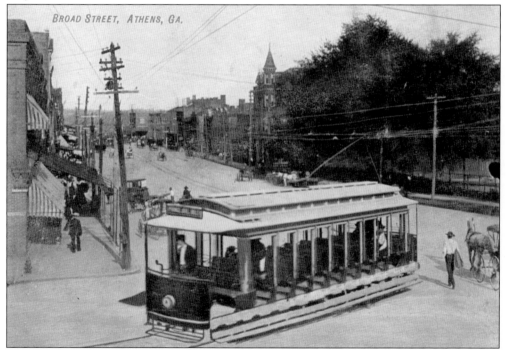

BROAD STREET, ATHENS, GA.

This is another picture of the same intersection, showing a streetcar making the turn from Broad Street onto College Avenue.

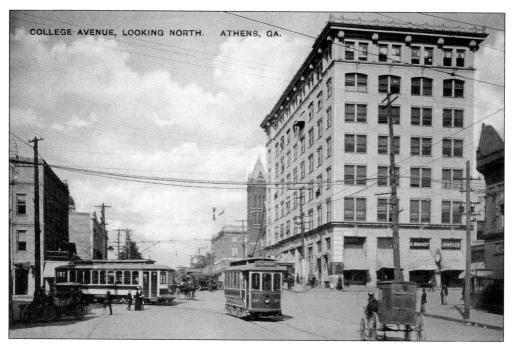

This remarkable view looking up College Avenue a few years later shows the old and the new: a horse-drawn wagon, automobiles, and streetcars.

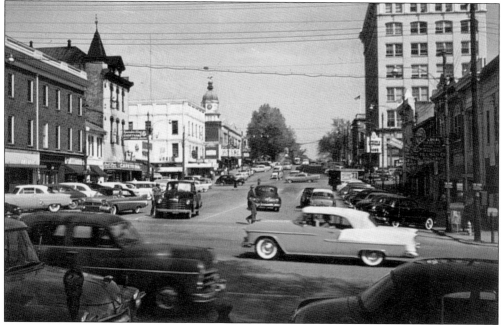

Facing College Avenue from Broad Street in the 1950s is like peering into an antique automobile museum. Several now-vintage automobiles can be identified, including a 1955 Chevrolet convertible, a 1947 Plymouth sedan, and a 1950 Chevrolet pickup truck. Several landmarks also can be seen: the Varsity, Davis Brothers Cafeteria, and the Palace Theater. The C&S Bank was in the corner of the Southern Mutual Building.

The General Elijah Clarke Monument was erected in 1904 to honor the Revolutionary War hero for whom Clarke County is named. The monument was originally placed at the intersection of College Avenue and Hancock Avenue but was moved in 1907. It now stands in the middle of Broad Street between College Avenue and Lumpkin Street. The Confederate Monument can be seen half a block further down, in front of the UGA Arch.

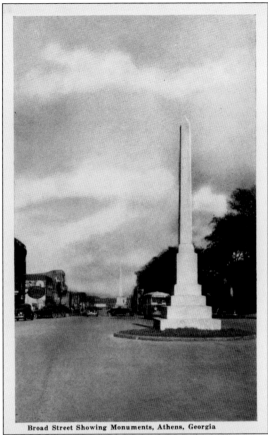

Broad Street Showing Monuments, Athens, Georgia

The Confederate Monument is in the foreground in this view, and the General Elijah Clarke Monument is seen further up Broad Street. Originally located at the intersection of College Avenue and Washington Street, the cornerstone of the Confederate Monument was laid on May 5, 1871. The 32-foot-high monument was moved to the Broad Street site in 1912. The space between the Clarke and Confederate Monuments was enclosed with curbing, and a small park was established.

A9 BROAD STREET, SHOWING CONFEDERATE AND CLARKE MONUMENTS, ATHENS, GA.

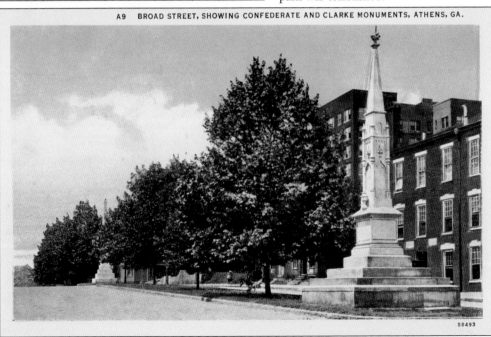

58493

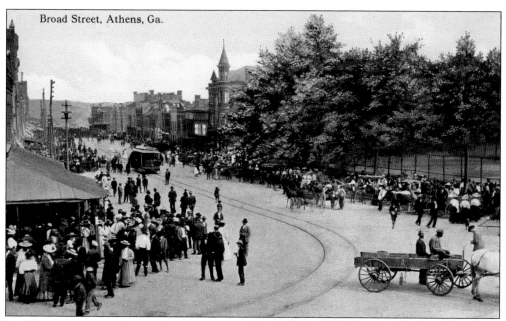

Looking east on Broad Street from the intersection with College Avenue on a busy day around 1907 shows a large crowd of people gathered on either side of the street, probably due to some special event or festival. Farther down Broad Street at the intersection with Jackson Street is the former Joel Building, which was the home of Athens Refrigeration and Appliance Company from 1946 to 1995.

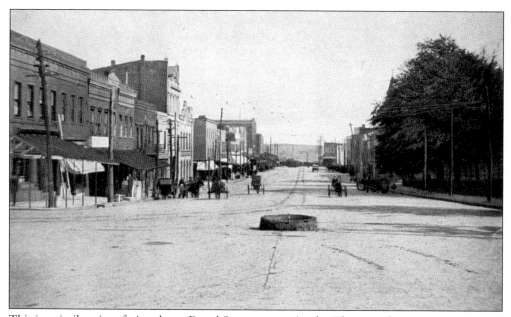

This is a similar view, facing down Broad Street on a quiet day. The stone horse-watering trough in the middle of the intersection is quite prominent.

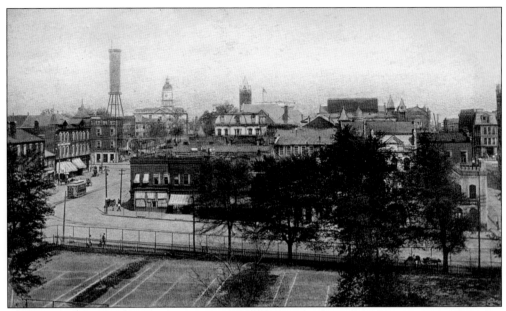

Looking across Broad Street from inside the campus before 1908 offers a good view of the clay tennis courts along the fence. The mansard roof of the old 1876 Southern Mutual Building on the corner of College Avenue and Clayton Street can be seen. Also, the steeple of Athens Baptist Church and the water tower on the grounds of city hall are visible.

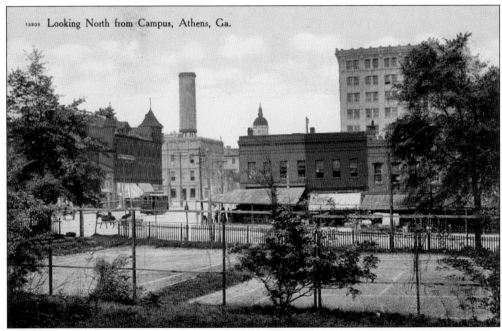

This is a similar view a few years later, showing the top of the new Southern Mutual Building that replaced the old structure in 1908.

The Athenaeum Club was built on the corner of Broad and Lumpkin Streets in 1884. By 1914, the building was home to the Elks Club. In 1919, the University of Georgia bought the building for use as the UGA School of Law, and it remained here until Hirsch Hall was completed on the campus in 1932. The structure was demolished in 1941, and the site now is a parking lot for Bank of America.

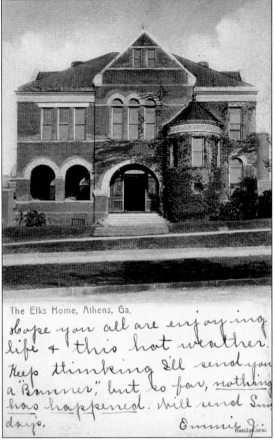

The Elks Home, Athens, Ga.

Hope you all are enjoying life & this hot weather. Keep thinking I'll send you a "Runner," but so far, nothing has happened. Will send Sun days.

Emmie J.

This is a view of the Athenaeum Club/ Elks Home/School of Law as the building aged and became covered with English ivy.

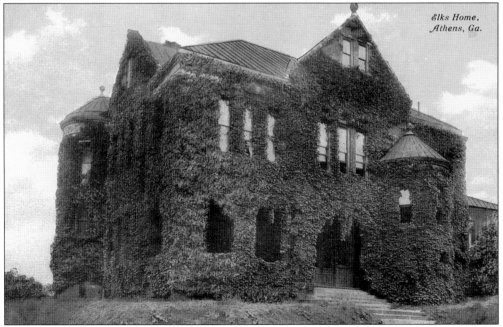

Elks Home, Athens, Ga.

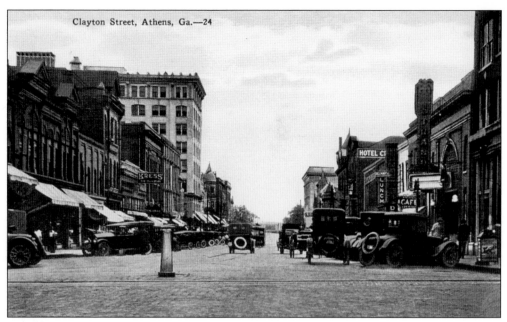

An early-1920s view of Clayton Street looking east from Lumpkin Street shows a sundial in the middle of the street and many vintage automobiles. Some well-known Athens landmarks seen here that no longer exist are the Strand Theater and S.H. Kress & Company.

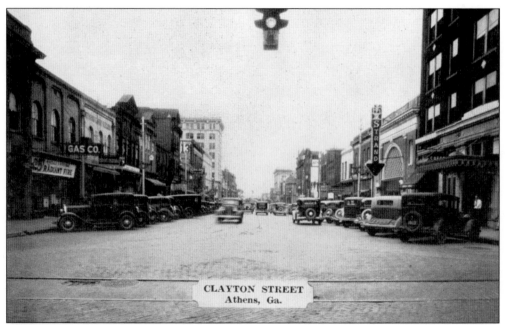

In this same view from the mid-1930s, one can see that the sundial is gone and the marquee of the Strand Theater has changed. This provides a good view of the entrance to the old Holman Hotel, now Bank of America.

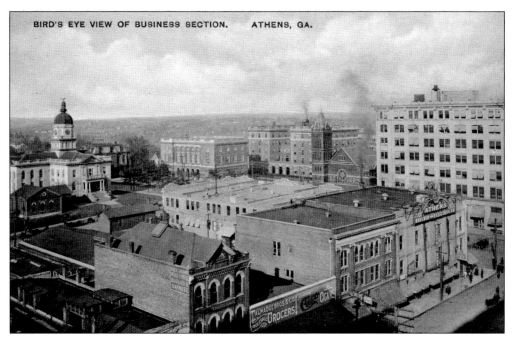

This bird's-eye view looking northeast from the Holman Building shows a large part of downtown Athens, including city hall, the old Southern Mutual Building after it was moved, the Federal Building, the Georgian Hotel, Athens Baptist Church, and the new Southern Mutual Building.

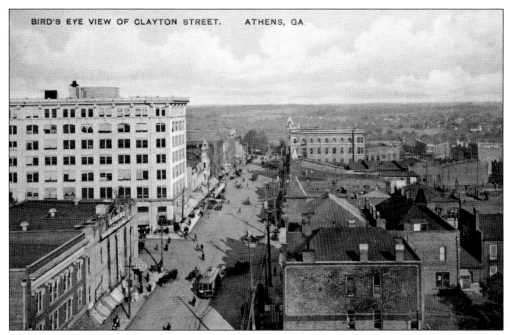

Another bird's-eye view looking east from the Holman Building down Clayton Street reveals some interesting landmarks. On the corner of Clayton Street and College Avenue is the Shackleford Building, which at this time was the home of Athens Railway & Electric Company. Near the end of Clayton on the right is the Michael Brothers department store that burned in 1921.

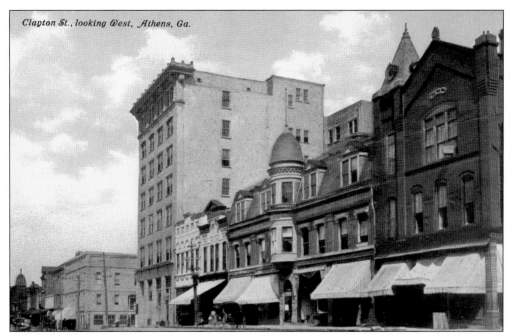

Clayton St., looking West, Athens, Ga.

The buildings seen when looking down West Clayton Street from Jackson Street are all still standing. The upper parts of many of these buildings remain unchanged since this photograph was taken around 1910. The building on the right at the corner of Jackson Street was home to Davison-Nichols Company, which later was the location of Foster's Jewelers. Next door was McClellan's Variety Store, the first air-conditioned store in Athens.

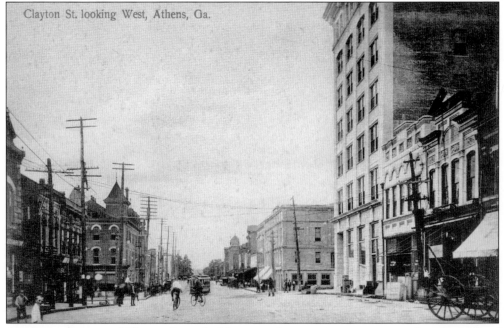

Clayton St. looking West, Athens, Ga.

Another early view of Clayton Street looking west shows some structures on the other side of the street.

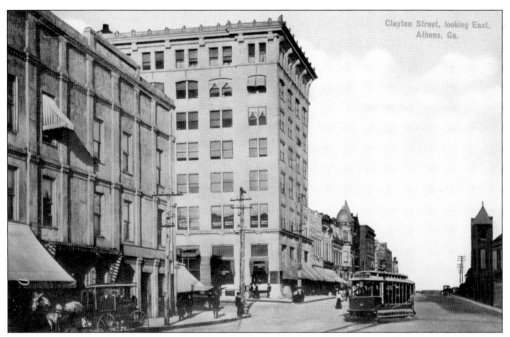

An eastward view down Clayton Street shows a streetcar making a turn off College Avenue. The Shackleford Building is on the corner on the left, and across College Avenue, one can see the new Southern Mutual Building.

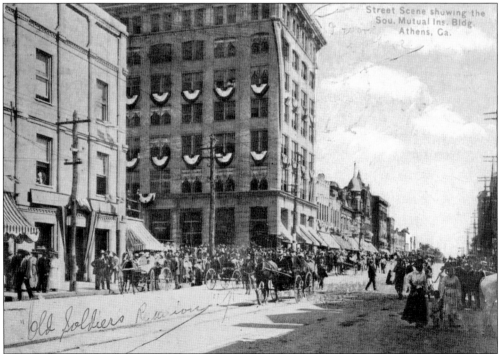

The same view shows part of a Confederate Veterans Parade on April 26, 1910. Beginning soon after the end of the War Between the States, Confederate Memorial Day was celebrated annually across the South with picnics, parades, speeches, and fireworks.

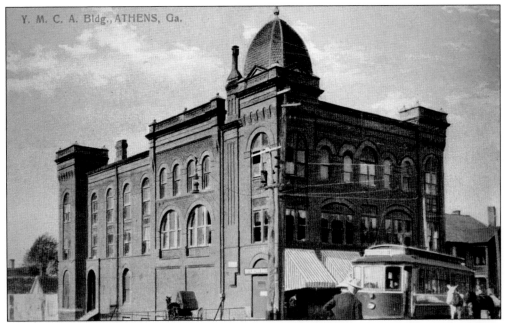

The YWCA Gymnasium was built on the corner of Hancock Avenue and Pulaski Street in 1913. The Stevens Thomas home on the large lot was moved aside to make room for the Y. When the YWCA moved to its present location on Research Road in 1981, this building was bought by investors and rented for office space.

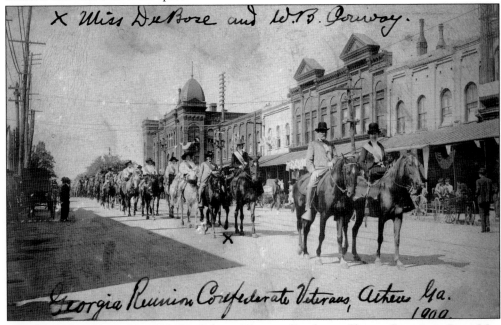

The first lady rider in this 1909 Confederate Veterans Parade on Clayton Street was Lucy May Stanton, a world-famous Georgia-born artist. Her sister Willie Marion Stanton married an Athenian, and Lucy lived in Athens off and on. She died in Athens in 1931 and is buried in Oconee Hill Cemetery. The second couple in the parade, marked with an "X," is Louise DuBose and Dr. William Buchanan Conway. (Courtesy of Patrick Mizelle.)

Two

THE UNIVERSITY OF GEORGIA CAMPUS

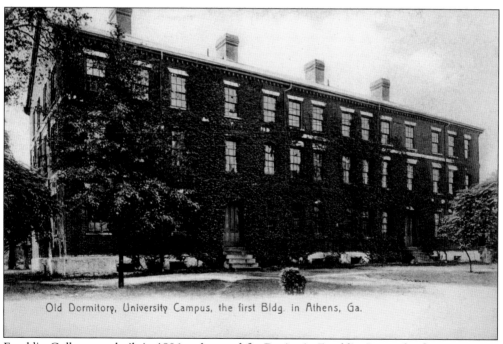

Old Dormitory, University Campus, the first Bldg. in Athens, Ga.

Franklin College was built in 1806 and named for Benjamin Franklin. It was the first permanent building on the University of Georgia campus. Now known as Old College, it was built in the image of Connecticut Hall at Yale University, from which UGA president Josiah Meigs and several members of the university's founding committee had graduated. The building currently houses the offices of the Franklin College of Arts and Sciences.

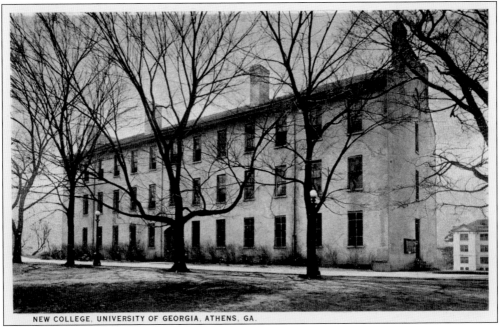

NEW COLLEGE, UNIVERSITY OF GEORGIA, ATHENS, GA.

New College was first built in 1823 as a four-story structure for a dormitory, classrooms, and a library. The building burned in 1830 but was rebuilt in 1832 with only three stories. Like many other older buildings on campus, this edifice has served myriad purposes, including a snack bar, bookstore, pharmacy school, psychology department, and administrative offices.

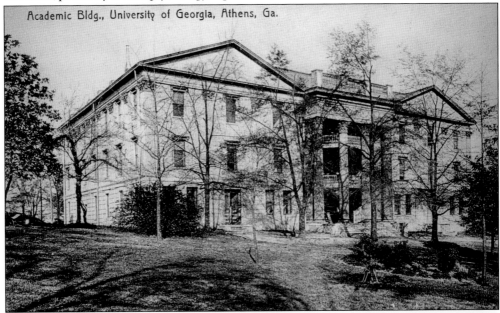

Academic Bldg., University of Georgia, Athens, Ga.

The Academic Building was created in 1905 by joining the Ivy Building, constructed in 1831, and the library next door, erected in 1862. The Academic Building has always been used for UGA business offices. In 2001, it was renamed Holmes/Hunter Academic Building to honor Hamilton Holmes and Charlayne Hunter-Gault, UGA's first African American students, who integrated the campus in 1961.

The cast-iron arch, the symbolic entrance to UGA's old North Campus, and the iron fence surrounding that section of the college grounds were cast at the Athens Foundry about 1856. The arch is fashioned after the Georgia State Coat of Arms; the three columns represent wisdom, justice, and moderation.

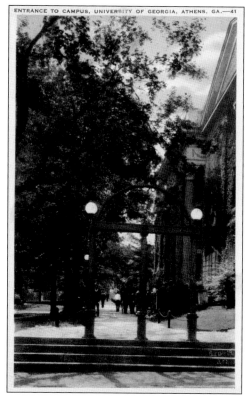

ENTRANCE TO CAMPUS, UNIVERSITY OF GEORGIA, ATHENS, GA.—41

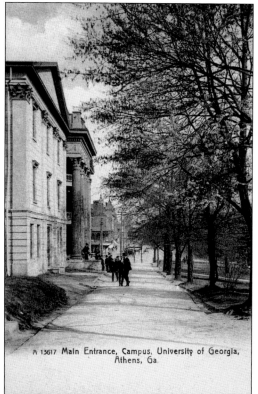

A 13617 Main Entrance, Campus, University of Georgia, Athens, Ga.

The main entrance to the North Campus quadrangle is via the UGA Arch. The sidewalk passes in front of the Academic Building, the UGA Chapel, New College, and onward. In the 1920s, streetlights were put in place along the sidewalk. In an effort to promote fellowship, students were encouraged to speak to everyone they met on the walk, appropriately called the "Hello Walk."

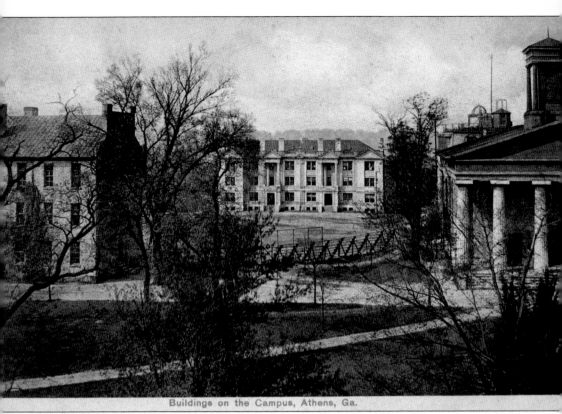

Herty Field was a sports venue located in the vacant space behind New College and the UGA Chapel. Candler Hall and Moore College comprised the other boundaries. In 1896, the area was named for Dr. Charles Holmes Herty, a UGA chemistry professor who was the university's first football coach. As sports on campus became more popular, especially baseball and football, the venue was moved in 1911 to a site on Lumpkin Street to accommodate larger crowds. Herty Drive was created through the area, and a parking lot filled the rest of the site that had been Herty Field. In 1999, an attractive parklike area was established, along with the installation of a fountain.

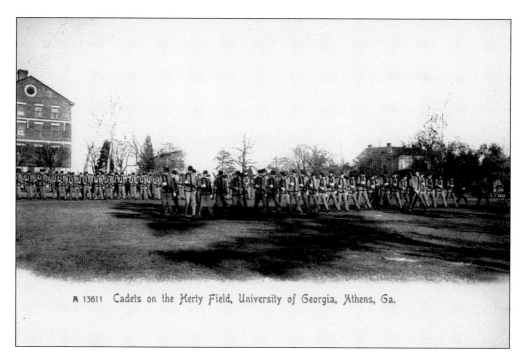

A 13611 Cadets on the Herty Field, University of Georgia, Athens, Ga.

The UGA Cadet Corps was established in 1872, just seven years after the end of the War Between the States, and the original uniform was Confederate gray in color. When the university was required to change the color to khaki during World War I, the United Daughters of the Confederacy protested in writing to Chancellor David C. Barrow Jr. Herty Field provided an ideal place for the cadets to drill.

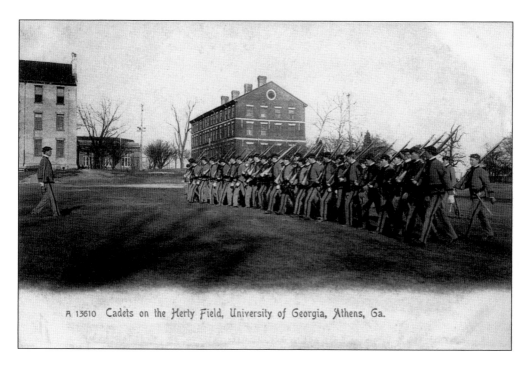

A 13610 Cadets on the Herty Field, University of Georgia, Athens, Ga.

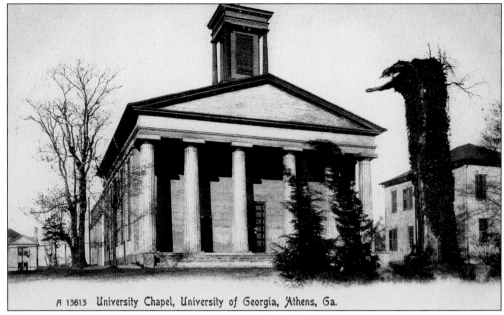

A 13613 University Chapel, University of Georgia, Athens, Ga.

The UGA Chapel, constructed in 1832, is one of the earliest Greek Revival buildings in Athens. The chapel bell originally was housed in a cupola atop the chapel. When the cupola was removed in 1913, the bell was placed in a tower behind the chapel and became a popular way to signify university athletic victories.

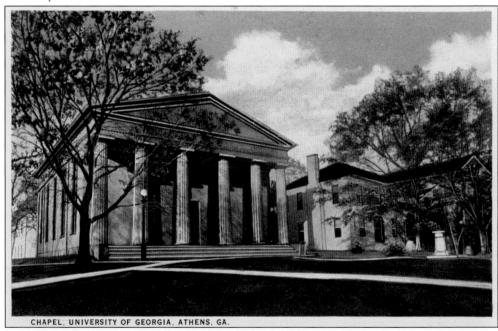

CHAPEL, UNIVERSITY OF GEORGIA, ATHENS, GA.

The Toombs Oak was named for Robert Augustus Toombs, an early student at the university who became a famous lawyer, senator, congressman, Confederate cabinet member, and brigadier general in the Confederate army. The Toombs Oak stump remained in front of the chapel for many years after the tree was struck by lightning in 1884. The snag fell during the night of July 5, 1908, and a sundial now occupies the spot.

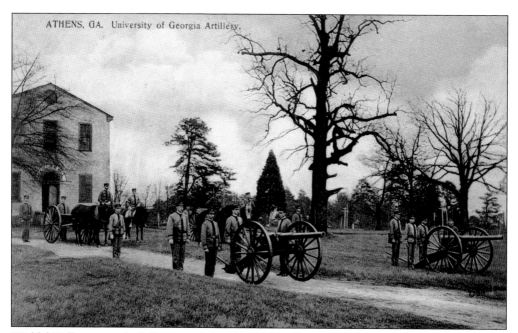

Waddel Hall, seen on the left, was completed in 1821 and is the second oldest building on campus. The building has served many purposes over the years and has variously been named Philosophical Hall and Agricultural Hall. When UGA registrar Thomas Walter Reed lived in this building during his 36-year tenure, it was known as Reed House. In this c. 1907 view, UGA cadets drill in the quadrangle out front.

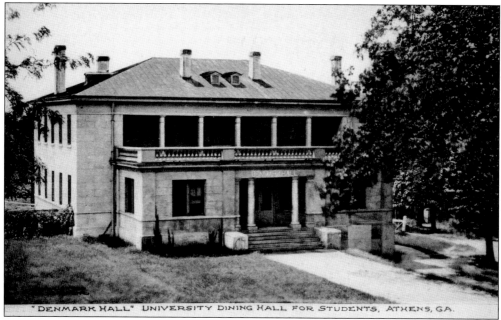

Denmark Hall, built in 1901, was named in memory of Brantly Astor Denmark, who graduated in 1871 and was a successful fundraiser for UGA projects. Denmark was president of the Bank of Savannah and the Southwestern Railroad. He was on the UGA Board of Trustees and a curator of the Georgia Historical Society. Denmark died in 1901.

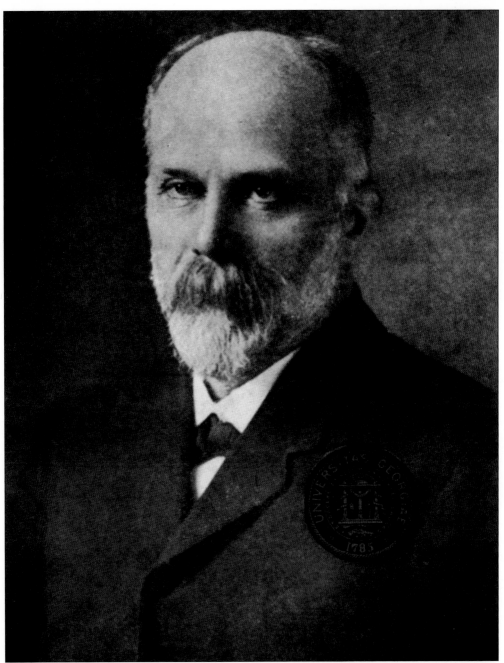

Chancellor David Crenshaw Barrow Jr. was born in nearby Oglethorpe County in 1852 and graduated from UGA in 1874. After a short stint practicing law, Barrow began his career at UGA in 1878 as a mathematics teacher and later taught engineering. In 1898, he became dean of the liberal arts college. Barrow became chancellor in 1906, following the death of Chancellor Walter B. Hill. The university enjoyed unprecedented growth under "Uncle Dave" Barrow's administration, and he was loved by students and faculty alike. Barrow died in 1929. Among his many honors, Barrow had a UGA building, an Athens street, an Athens elementary school, and a Georgia county named for him.

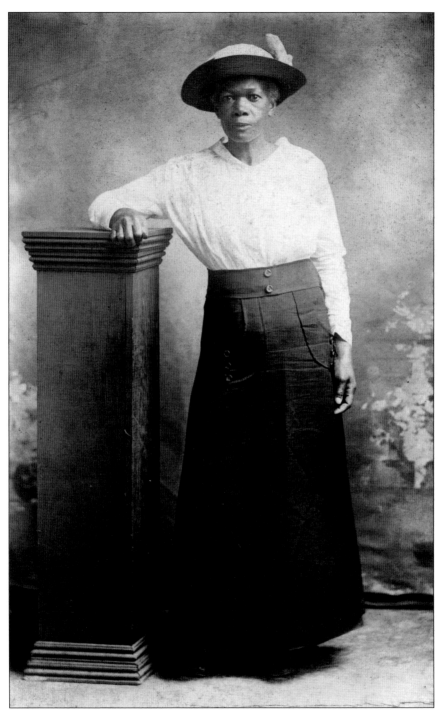

Addie B. Starks (1874–1946), pictured here in 1917, was the cook for UGA chancellor David Crenshaw Barrow Jr. Chancellor Barrow attested that Addie Starks was "one of the best women I know, black or white." Addie was the mother of Ples "Clegg" Starks (1903–1964), the famous water boy for the UGA football team under 12 head coaches. Addie and Clegg Starks are buried in Brooklyn Cemetery behind Holy Cross Lutheran Church on West Lake Drive.

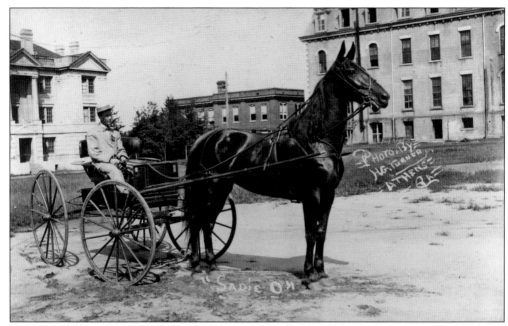

"Sadie O" was a magnificent horse that belonged to Athenian R.P. Whitehead. An item in the October 18, 1907, issue of the *Weekly Banner* proclaimed her to be "one of the prettiest and finest horses in the state." Here, she poses on Herty Field. In the background, Candler Hall is on the left, Meigs Hall is in the center, and Moore College is on the right.

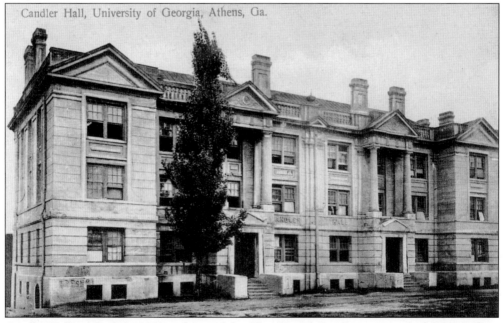

Candler Hall was built in 1902 and named for Allen Daniel Candler, governor of Georgia from 1898 to 1902. The building alternately was a boys' dormitory, a girls' dormitory, and then a boys' dormitory again. Later, it was home to the Department of Germanic and Slavic Languages. It now houses the Honors Program, Foundation Fellowship Program, and Center for Undergraduate Research Opportunities (CURO).

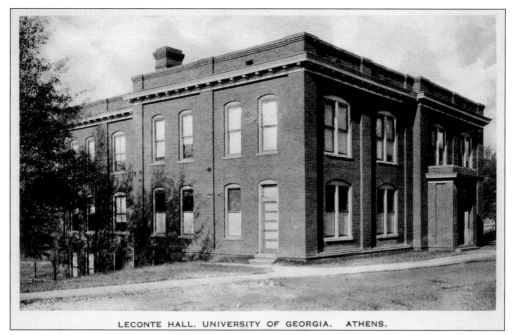

Meigs Hall, built in 1906, was first named LeConte Hall for UGA professor Joseph LeConte, who was on the faculty along with his brother John. The brothers eventually relocated to California and helped establish the University of California at Berkeley. A new LeConte Hall was constructed in 1937, and the name of this older building was changed to Meigs Hall in honor of early UGA president Josiah Meigs.

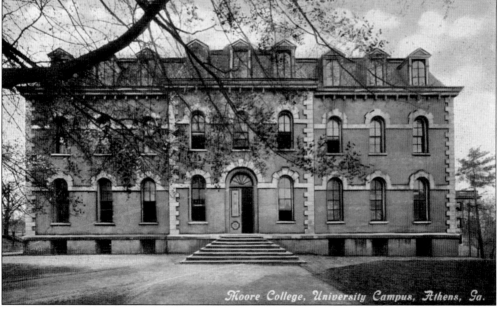

Moore College, University Campus, Athens, Ga.

Moore College was built in 1874 to be used as the State College of Agriculture and the Mechanical Arts. The college was promoted by local physician and UGA graduate Dr. Richard Dudley Moore, who served on the UGA faculty and was a member of the university's board of trustees. Dr. Moore persuaded the City of Athens to contribute $25,000 toward construction of the building.

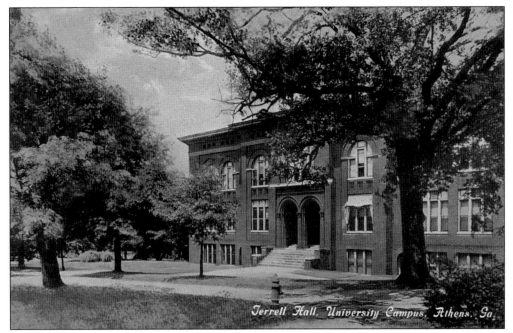

Terrell Hall, built in 1904, was named in memory of Dr. William Terrell, a staunch supporter of UGA when he served in the Georgia Legislature and the US Congress. In 1854, a year before his death, Dr. Terrell gave $20,000 to UGA to endow a chair of agriculture, the first endowed chair on campus and the first liberally endowed chair of agriculture in the United States.

A street system that once traversed the North Campus quadrangle closely followed the sidewalk arrangement that exists today. The streets had two accessions on Broad Street, two on Jackson Street, and one on Lumpkin Street. In this scene, the street passes in front of Peabody Hall.

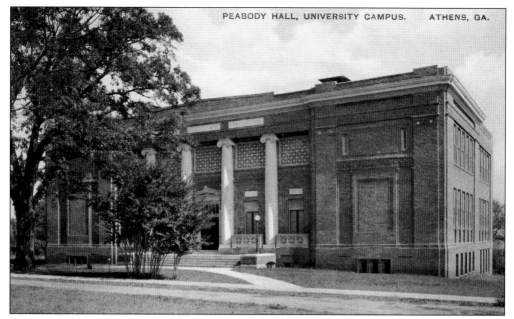

There were two benefactors to the University of Georgia named George Peabody. The Peabody that this building is named for was a prosperous merchant from New England who died in 1869 and had made arrangements in his will for the distribution of his wealth to Southern states devastated during the War Between the States. This building was completed in 1913, partially paid for with $40,000 from the Peabody Fund.

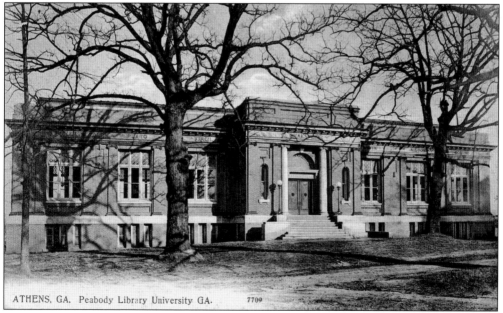

ATHENS, GA. Peabody Library University GA. 7709

The other Peabody benefactor was George Foster Peabody, a native of Columbus, Georgia, who became a wealthy New York banker. He also developed Edison Electric Illuminating Company, which became General Electric Corporation. Peabody retired in 1906 and spent the remainder of his life in philanthropy. The University of Georgia was a major recipient of his support. The Peabody Awards, named in his memory, have been awarded annually since 1940.

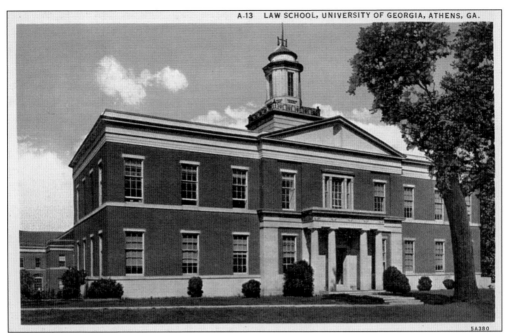

Hirsch Hall, home of UGA's School of Law, was completed in 1932 and named for a generous benefactor, Harold Hirsch, who received a bachelor of arts degree from UGA in 1901, then earned a law degree from Columbia University. Hirsch was legal counsel and vice president of the Coca-Cola Company and served on the board of directors for several large companies. Hirsch was second only to George Foster Peabody in his support of UGA.

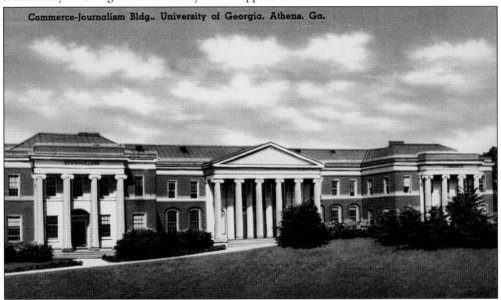

Commerce-Journalism Bldg., University of Georgia, Athens, Ga.

The Commerce-Journalism Building was constructed in 1928 with money left over from the fundraising campaign to build Memorial Hall. It housed the School of Commerce and the School of Journalism and was called the C-J Building. The name was changed in 1961 in memory of 1904 graduate Dr. Robert Preston Brooks, UGA's first Rhodes Scholar and dean of the School of Commerce from 1920 to 1945.

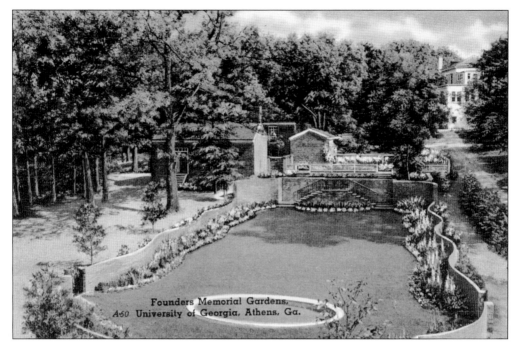

Founders Memorial Garden was completed in 1940 as a tribute to the charter members of the first ladies' garden club in America, which was founded in Athens in 1891. The garden is located on Lumpkin Street between an 1857 faculty house and the back of Brooks Hall. The garden was developed by Hubert B. Owens, later dean of UGA's School of Landscape Architecture.

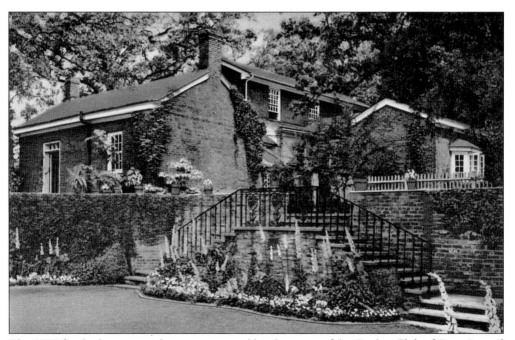

The 1857 faculty house served as a museum and headquarters of the Garden Club of Georgia until the club moved to new quarters at the State Botanical Garden of Georgia.

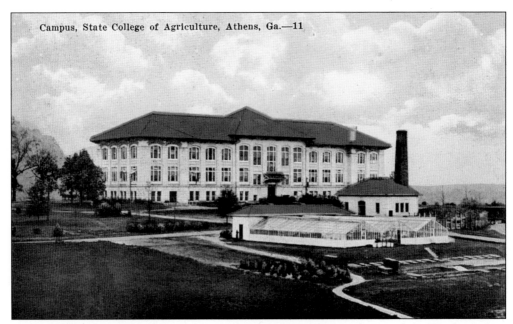

Conner Hall was completed in 1908 as the State College of Agriculture and the Mechanic Arts. This Renaissance Revival edifice was initially called Agricultural Hall but was renamed in 1923 to honor James J. Conner, a state legislator who was a strong supporter of agricultural education. In 1932, the name was changed to the College of Agriculture, but later became the College of Agriculture and Environmental Sciences.

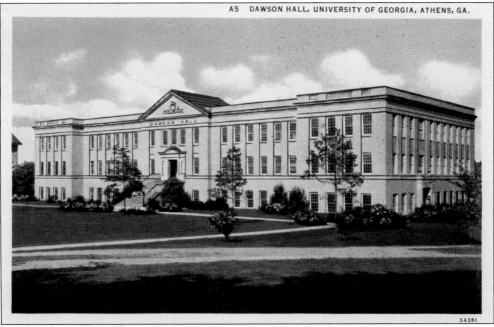

A5 DAWSON HALL, UNIVERSITY OF GEORGIA, ATHENS, GA.

Dawson Hall was built in 1932 with funds willed to UGA by William Terrell Dawson, who allowed for his bequest to be used for any purpose designated by Dr. Andrew M. Soule, president of the College of Agriculture and the Mechanic Arts. The building currently is used by the College of Family and Consumer Sciences.

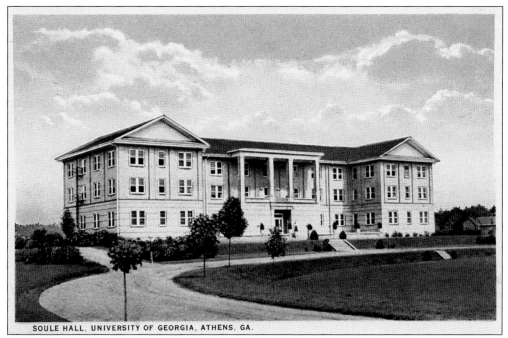

SOULE HALL, UNIVERSITY OF GEORGIA, ATHENS, GA.

Soule Hall, completed in 1920 as the first girls' dormitory on campus, was named for Dr. Andrew M. Soule, president of the College of Agriculture and the Mechanic Arts and dean of the College of Agriculture. Women were not allowed to attend UGA until 1903, when females who were training to be teachers at other institutions were permitted to attend summer school classes. In 1918, the first females were admitted as regular students.

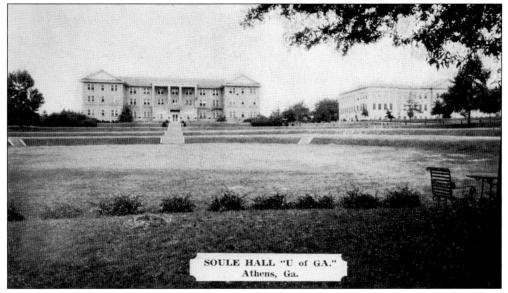

SOULE HALL "U of GA."
Athens, Ga.

A large amphitheater was developed in 1922 on what is now D.W. Brooks Drive behind Soule Hall. The back of Dawson Hall, built in 1932, also can be seen in this view. The amphitheater was used for assemblies, graduation exercises, visiting speakers, and some sports events. The area was leveled in 1967 to make way for what is now Boyd Graduate Studies Center, which houses the Science Library.

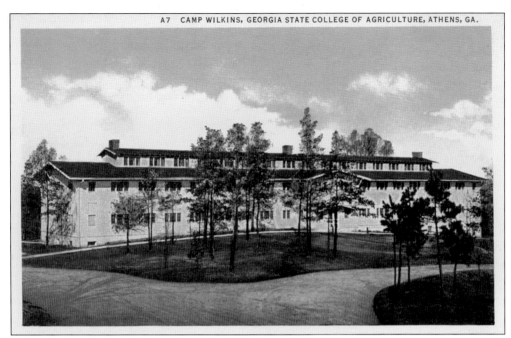

Camp Wilkins was a large wooden and stucco building put up on the former farmland of the John J. Wilkins family in 1924 on what is now Agricultural Drive. Primarily used to accommodate summer 4-H campers, students in financial need also were housed there. When the US Navy Pre-Flight School occupied the campus during World War II, it served as a dormitory. Driftmier Agricultural Engineering Center now occupies the site.

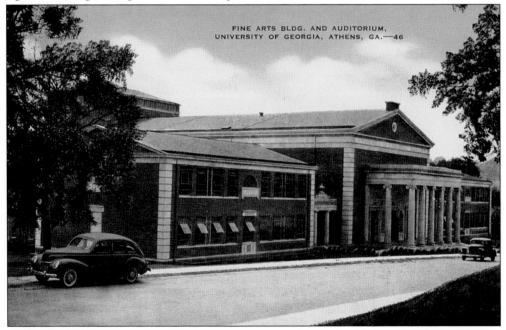

The Fine Arts Building and Auditorium was constructed in 1941 with funds provided by Pres. Franklin D. Roosevelt's Public Works Administration. The facility has undergone extensive renovation in recent years and is still in use.

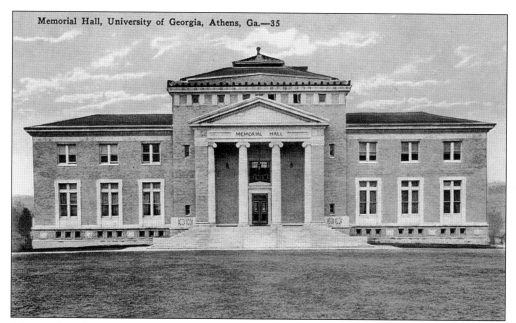

Memorial Hall was established in 1910 as the YMCA. In 1912, the unfinished building began service as a gymnasium with a swimming pool and was called Alumni Hall. After World War I, a campaign was waged to complete the building as a memorial to the 47 UGA students and faculty who died during the war. More than $1 million was raised, and the building was completed in 1925.

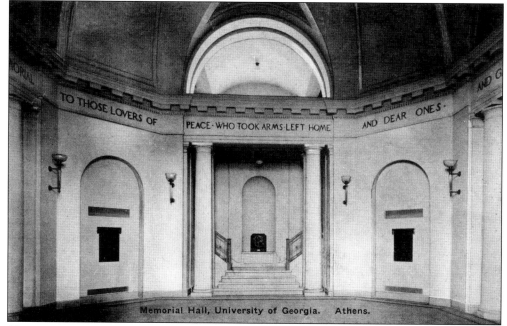

Above is a view of the interior of Memorial Hall. Chancellor David Crenshaw Barrow Jr. wrote the inscription around the interior of the rotunda, which reads as follows: "In Loyal Love We Set Apart This House a Memorial to Those Lovers of Peace Who Took Arms, Left Home and Dear Ones, and Gave Life That All Men Might Be Free."

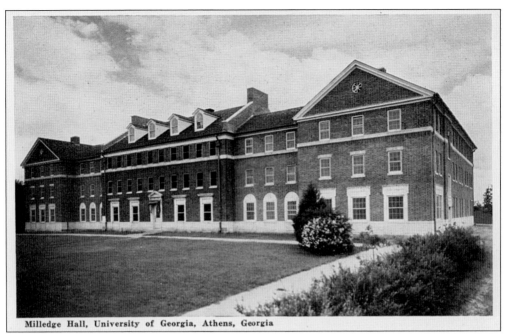

Milledge Hall, University of Georgia, Athens, Georgia

Milledge Hall was a built as a boys' dormitory in 1925, and the wings were added in 1939. It was named for John Milledge, one of the founders of the University of Georgia who bought the original 633 acres of land for the university and donated it to the state. Milledge was governor of Georgia from 1802 to 1806. When the US Navy Pre-Flight School occupied the campus during World War II, Milledge Hall was known as Wasp Barracks.

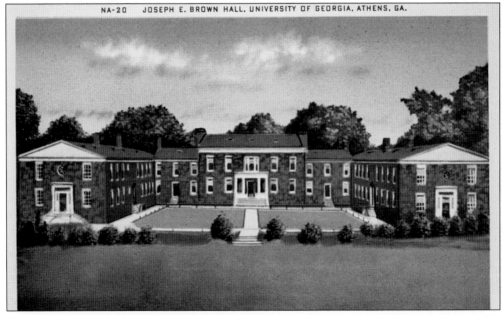

NA-20 JOSEPH E. BROWN HALL, UNIVERSITY OF GEORGIA, ATHENS, GA.

Joe Brown Hall was a boys' dormitory built in 1932 on the corner of Baldwin and Lumpkin Streets across from the auditorium. It was named for Joseph Emerson Brown, governor of Georgia from 1857 to 1865, who later served as a US senator. In 1882, Brown gave the university $50,000 to honor his son Charles McDonald Brown, who died in 1881.

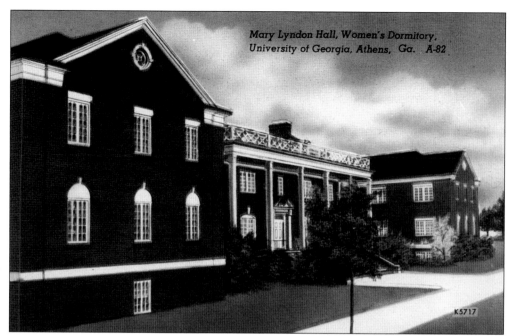

*Mary Lyndon Hall, Women's Dormitory,
University of Georgia, Athens, Ga. A-82*

K5717

Mary Lyndon Hall was built in 1936 as a girls' dormitory and named for Mary Dorothy Lyndon, who, in 1914, was the first female to receive a master's degree from UGA. In 1919, the board of trustees established a position for a woman to be associate professor of education, as well as the dean of women. Mary Lyndon was the first person to hold the position.

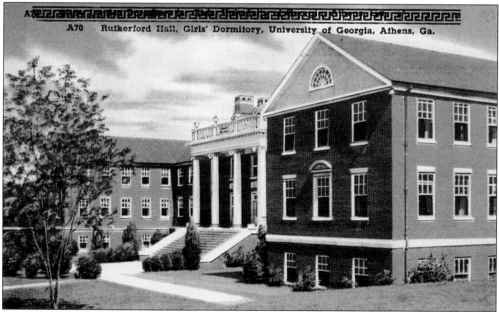

A70 Rutherford Hall, Girls' Dormitory, University of Georgia, Athens, Ga.

Rutherford Hall, another girls' dormitory, was completed in 1939 and named for Athenian Mildred Lewis Rutherford. "Millie" Rutherford was the daughter of Laura Cobb Rutherford, sister of Howell and T.R.R. Cobb. Millie Rutherford devoted her life to teaching and taught at Lucy Cobb Institute for more than 40 years, including a long stint as headmistress. She was teacher, friend, and confidante to hundreds of young ladies who attended Lucy Cobb.

45

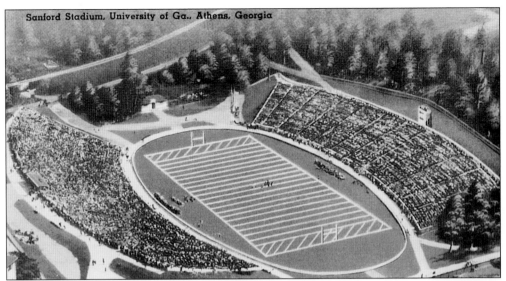

Sanford Stadium, University of Ga., Athens, Georgia

Sanford Stadium was named for Dr. Steadman Vincent Sanford, who came to UGA to teach English in 1903 and remained on the faculty for 42 years. Sanford held many teaching and administrative positions, including dean of the School of Journalism, university president, and, finally, chancellor. In addition, Sanford was faculty chairman of athletics for many years. He organized and was the first president of the Southern Conference. According to UGA faculty member Robert Preston Brooks, Sanford Stadium was "the child of the imagination and energy of Dean Sanford."

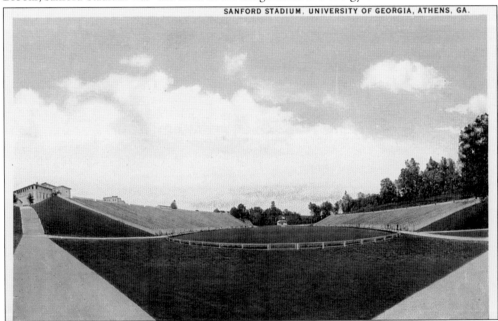

SANFORD STADIUM, UNIVERSITY OF GEORGIA, ATHENS, GA.

Sanford Stadium was completed in 1929, and the first football game played there took place October 12, 1929, between the Georgia Bulldogs and the Yale Bulldogs. Georgia won with a final score of 15-0. Sanford Stadium was built to seat 33,000, but with several additions throughout its existence, it now is the fifth largest college stadium in the country and can accommodate 92,058 fans. These very early views show the stadium as it looked before the famous hedges were planted around the perimeter of the playing field.

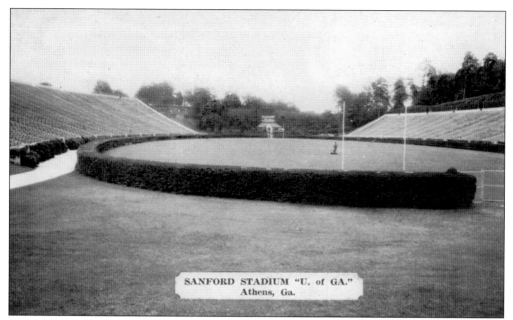

This is a later view of Sanford Stadium after the hedges were well established.

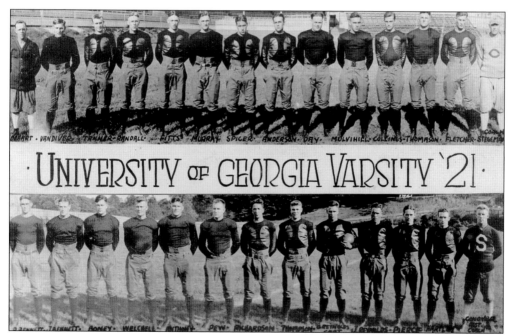

The Georgia football team had a 7-2-1 season in 1921, but because they beat Alabama, Auburn, and Clemson, it was considered a good year. They did not play Georgia Tech that year because the bitter rivalry that existed between the two schools since their first football game in 1893 had become so heated by 1919, all sports between UGA and Tech were suspended until 1924.

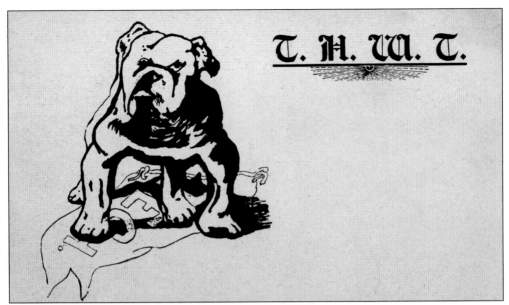

The rivalry between UGA and the Georgia Institute of Technology has existed for more than 100 years, as evidenced by this c. 1906 postcard showing a bulldog standing on a Tech pennant with the letters "T.H.W.T." (To Hell with Tech) above.

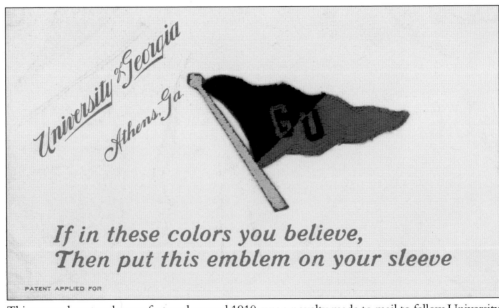

This unusual postcard, manufactured around 1910, was a novelty made to mail to fellow University of Georgia sports fans. The red and black pennant is an embroidered sticker that could be peeled off and worn on one's sleeve to express pride in the school, especially university athletics.

Three

SCHOOLS AND CHURCHES

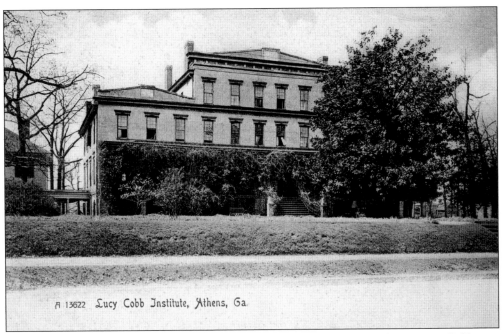

A 13622 Lucy Cobb Institute, Athens, Ga.

Lucy Cobb Institute was completed in 1859. Athenian Thomas Reade Rootes Cobb was instrumental in founding and financing what was to be Athens Female High School, but during construction, Cobb's 13-year-old daughter died of scarlet fever, and the name was changed to honor her memory. The school became known as one of the finest schools for young ladies in the country. It was closed in 1931 during the Great Depression.

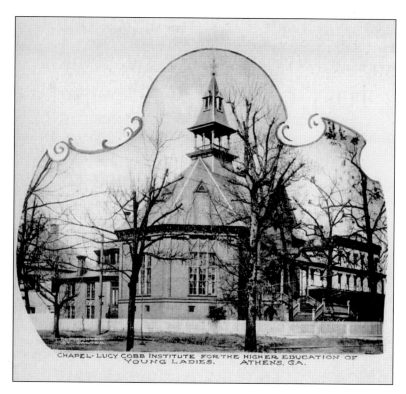

CHAPEL- LUCY COBB INSTITUTE FOR THE HIGHER EDUCATION OF YOUNG LADIES. ATHENS, GA.

Seney-Stovall Chapel was built as a result of an effort by the Lucy Cobb Institute principal, Mildred Lewis Rutherford, to raise funds to build a chapel. Students were given the names of wealthy philanthropists to write and ask for donations. Nellie Stovall drew the name of George I. Seney of New York, who gave $10,000 toward the project. The cornerstone was laid in 1882, and the building was completed and dedicated in 1885.

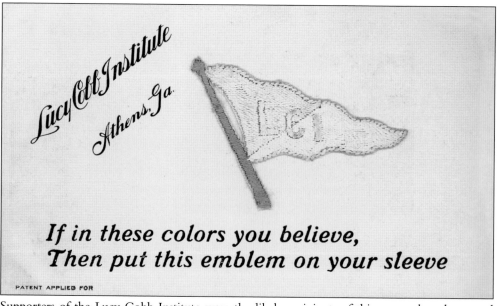

Lucy Cobb Institute Athens, Ga.

If in these colors you believe,
Then put this emblem on your sleeve

PATENT APPLIED FOR

Supporters of the Lucy Cobb Institute were the likely recipients of this postcard made around 1910. The unique embroidered sticker exhibiting the school's colors was meant to be peeled off and worn to show pride in the school.

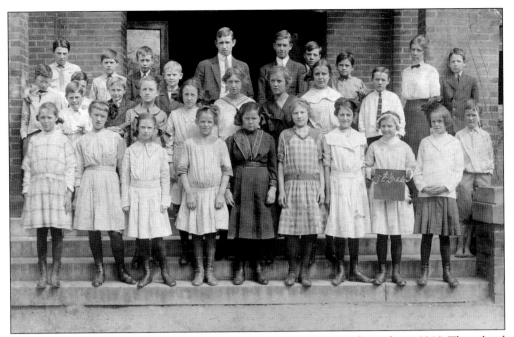

Bettie Wood's fifth-grade class at College Avenue School is shown here about 1910. The school building later became headquarters for administration offices for the Athens-Clarke County School District. The building was demolished in 2009 and is the present site of the Indigo Hotel.

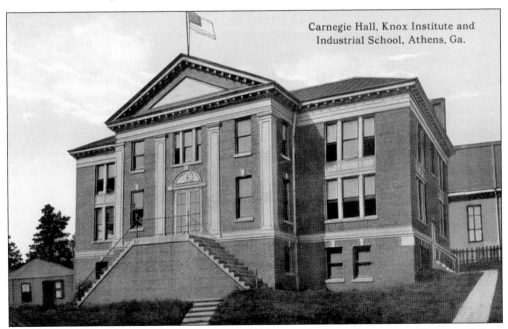

Carnegie Hall, Knox Institute and Industrial School, Athens, Ga.

Knox Institute and Industrial School for black children was built on the corner of Reese and Pope Streets in 1868. The school was named for Maj. John J. Knox, the Yankee officer who was the agent for the Bureau of Refugees, Freedmen, and Abandoned Lands in Athens during reconstruction. Carnegie Hall, shown here, was built in 1913 with funds provided by Andrew Carnegie. It was demolished in the 1950s, and the lot remains vacant.

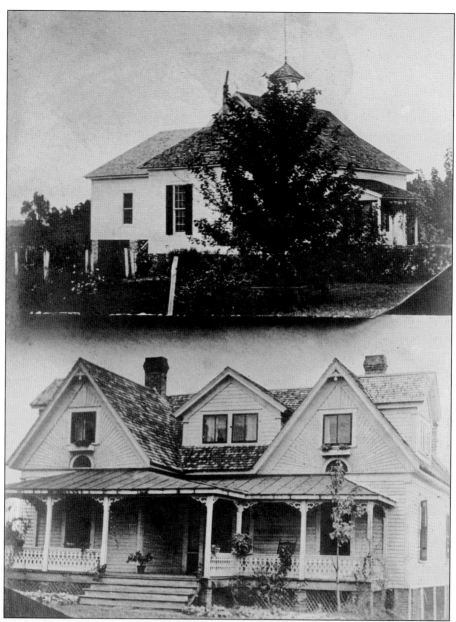

The Model and Training School for black students was founded in 1903 by Julia C. Jackson Harris on four acres of land she donated on the Danielsville Road north of Athens across the road from her home. The General Education Board of New York contributed money to build a three-room school building and a two-room home economics facility on the property. Clarke County provided the furnishings. The three-room school burned in 1926, but classes continued in the two-room structure and in Harris's home across the road until money could be raised to construct a new building. Julius Rosenwald, who contributed to the building or improvement of more than 5,000 black schools in the South, was the major benefactor for a four-room brick structure completed in 1929. The school closed in 1956, and the vacant boarded-up building remains standing. In this real-photo postcard, the original school building is shown at the top and Harris's home across the road is pictured at the bottom.

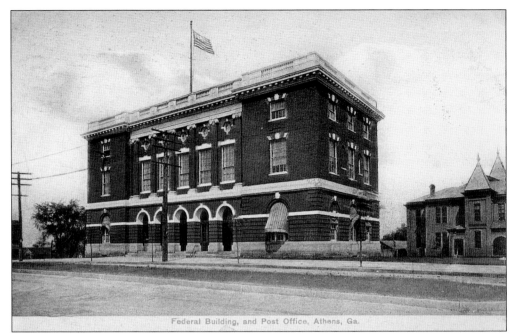

Federal Building, and Post Office, Athens, Ga.

Market Street School (later Washington Street School) was built between 1885 and 1890 on the corner of Market Street (now Washington Street) and Jackson Street. The school is seen here behind the Federal Building, which faced College Avenue. This is the only known postcard view of the school. The school building was demolished in 1908, and the Georgian Hotel was constructed on the site.

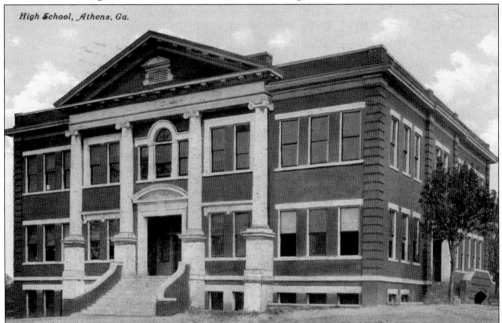

High School, Athens, Ga.

Athens High School was built on Childs Street in 1909 to replace the old Market Street/Washington Street school. In 1913, the high school was moved into the old Clarke County Courthouse on Prince Avenue and this became the Childs Street Junior High School. The school was destroyed by two teenaged arsonists in February 1966.

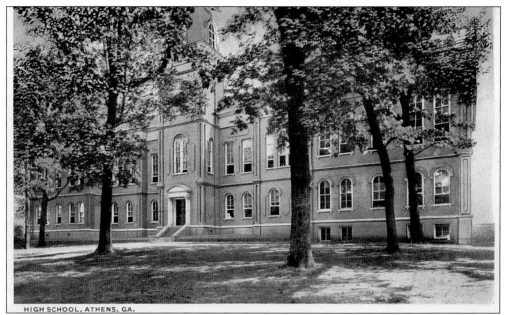

The old Clarke County Courthouse on Prince Avenue was sold to the city in 1913 for use as Athens High School. A wing was added to each side to provide more room. When the new Athens High School was completed on Milledge Avenue in 1953, this building was inherited by University Demonstration School and used by them until 1956, when the schools were consolidated. This building was demolished in 1959, and a Wendy's restaurant now occupies the site.

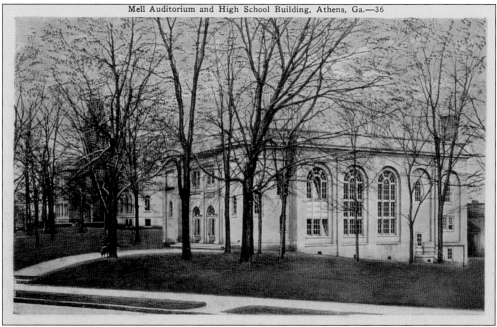

Mell Auditorium and High School Building, Athens, Ga.—36

Mell Auditorium was built next to Athens High School on Prince Avenue in 1923. It was named for Edward Baker Mell, a much-loved principal. A school lunch program was started after World War II, and the auditorium became a cafeteria in 1948. The building was demolished in the 1970s, and a Captain D's seafood restaurant was built on the site.

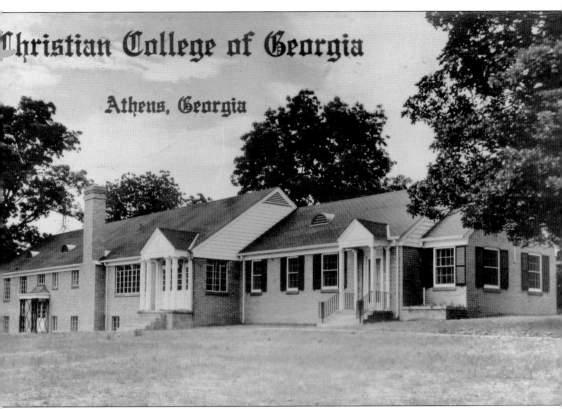

Christian College of Georgia

Athens, Georgia

The Christian College of Georgia, chartered in Atlanta in 1947, was authorized by the State of Georgia to grant diplomas, certificates, and degrees in religion, religious studies, and in disciplines related to Christian ministry. The facilities in Athens were located at 220 South Hull Street, and groundbreaking ceremonies were held in July 1948. The college later bought the historic Hull-Morton-Snelling House next door, which had been built about 1842. In 1990, the college demolished its buildings, including the Hull-Morton-Snelling House, and sold the property to the Holiday Inn across the street for use as a parking lot. The original agreement for instruction with the University of Georgia was discontinued in 1960, but the organization continues to function as Disciples on Campus from their church on South Lumpkin Street and serves students attending the University of Georgia, Gainesville State College, Piedmont College, and Athens Technical College.

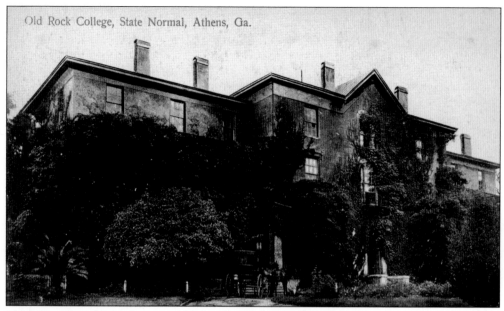

Old Rock College, State Normal, Athens, Ga.

The University of Georgia opened University High School on Prince Avenue in 1862 as a school to prepare young men to enter college. The school, housed in a single building constructed from concrete mixed with crushed stone, was called Rock College. The name was changed to Gilmer Hall, and it was the first of 13 buildings that eventually made up the State Normal School. The building was demolished in 1960.

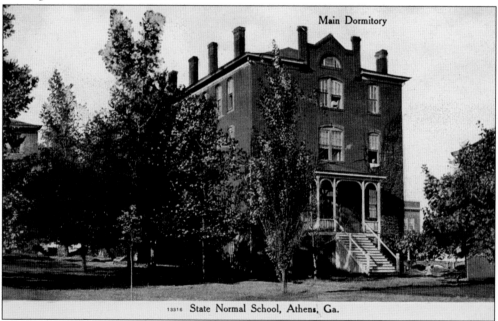

Main Dormitory

13316 State Normal School, Athens, Ga.

Bradwell Hall was the second building on the campus of the State Normal School. It was built in 1896 with an appropriation by the state legislature. Originally a two-story structure, a third story was added the next year with money provided by the faculty. It was named for Samuel Dowse Bradwell, second president of the school, who served from 1895 to 1901. The building was demolished in 1960.

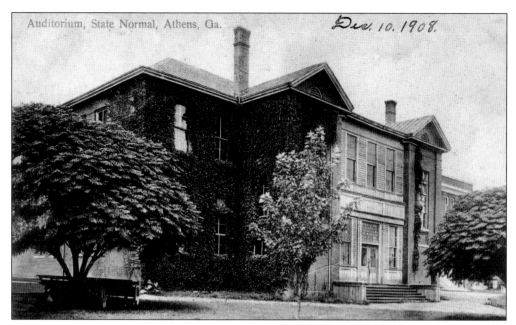

The auditorium at the State Normal School was built in 1898 with funding appropriated by the state legislature. The first floor was used as an auditorium, and the second floor was for classrooms. The student body soon outgrew the building. When Pound Auditorium was finished in 1917, the lower part of this building was used for the chapel, while the second story continued to be used for classes. The building was demolished in 1972.

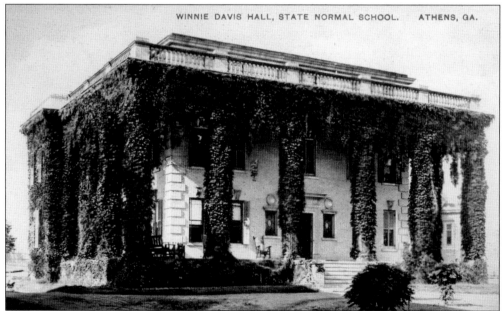

Winnie Davis Memorial Hall was built at the State Normal School in 1903 with money donated by the United Daughters of the Confederacy in memory of Varina Ann "Winnie" Davis, the daughter of Jefferson Davis, president of the Confederate States of America. Winnie Davis, who was born in the Confederate White House in Richmond in 1864, was popularly known as the "Daughter of the Confederacy." She died in 1898 at age 34. This building still stands today.

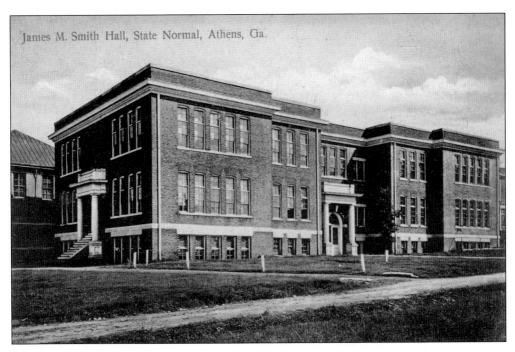

James M. Smith Hall, State Normal, Athens, Ga.

The James Monroe Smith Building and the dining hall at the State Normal School were both constructed in 1906. Part of the cost was donated by wealthy farmer James M. Smith, who was from nearby Oglethorpe and Madison Counties. Smith donated $10,000, George Foster Peabody gave $10,000, and many other Georgia citizens raised a total of $5,000. This was matched by $25,000 appropriated by the state legislature. The Smith Building was demolished in 1972, and the dining hall still stands.

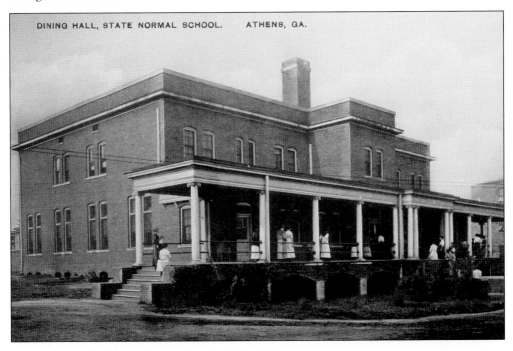

DINING HALL, STATE NORMAL SCHOOL. ATHENS, GA.

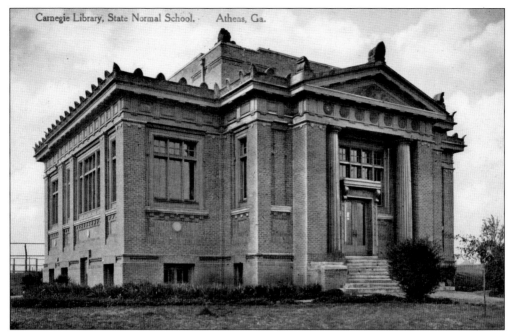

Carnegie Library, State Normal School. Athens, Ga.

In 1910, Carnegie Library was built at the State Normal School with $25,000 donated by Andrew Carnegie. The building was used as a library until the property was taken over by the US Navy Supply Corps School in 1952. The school used the facility as a museum until they vacated the property in 2010. The building still stands.

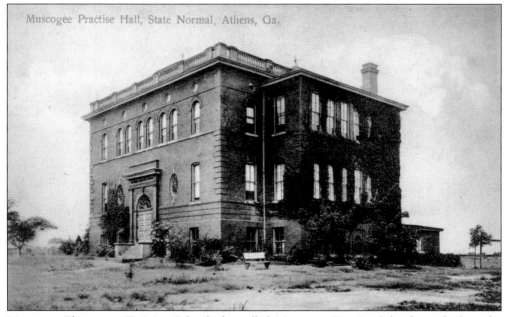

Muscogee Practise Hall, State Normal, Athens, Ga.

Muscogee Elementary Training School, also called Muscogee Practice School, was built at the State Normal School in 1902 with funds donated by George Foster Peabody. The school was so named because Peabody was a native of Muscogee County, Georgia. The school was attended by local rural children and provided practical experience in teaching for senior students at the State Normal School.

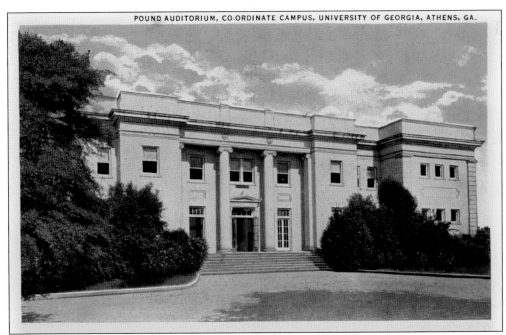

Pound Auditorium at the State Normal School was completed in 1917 and named for Jere M. Pound, president of the school from 1912 to 1932. This building replaced the old auditorium constructed in 1898, which was no longer sufficient to accommodate the student body. Pound Auditorium could seat 2,500 and still stands today. This is a view of Pound Auditorium after the State Normal School became part of UGA's Coordinate Campus in 1932.

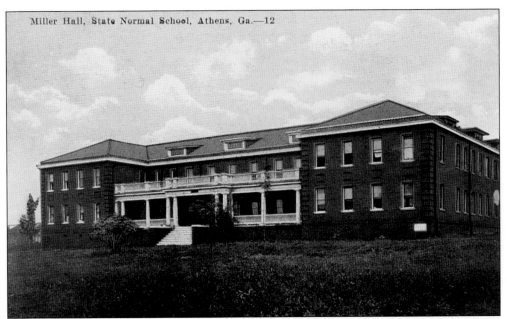

Construction for the Miller Hall dormitory at the State Normal School was completed in 1917 and named for Brick Stonewall Miller, a lawyer from Columbus, Georgia, who was president of the board of trustees. The building still stands.

60

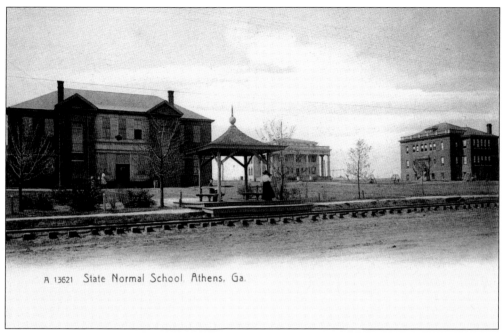

A 13621 State Normal School, Athens, Ga.

The Buzzard's Roost was an ornate shelter that served as a streetcar stop in front of the State Normal School. It was so named by UGA male students because of the long black dresses the girls were required to wear as uniforms.

VIEW OF STATE NORMAL SCHOOL, ATHENS, GA.

This is a distant view of the State Normal School campus from Buena Vista Avenue where the streetcar tracks turned onto Prince Avenue.

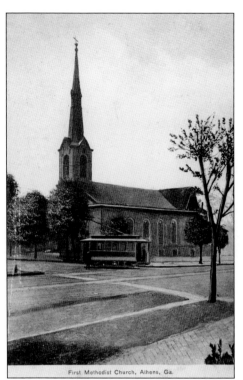

First Methodist Church stands at 327 North Lumpkin Street between Washington Street and Hancock Avenue. It replaced an earlier building put up in 1824. The building seen here was completed in 1852. This building still stands but has been largely enveloped by additions over the years. The original steeple remains in place.

First Methodist Church, Athens, Ga.

The black Methodists in Athens attended the white church on Lumpkin Street until 1852, when the new Methodist Church building was completed. The black members had wanted their own church, so the old 1824 frame building was given to them and moved four blocks to the intersection of Hancock Avenue and Foundry Street. The church can be seen in the distance in this early view from the Oconee River.

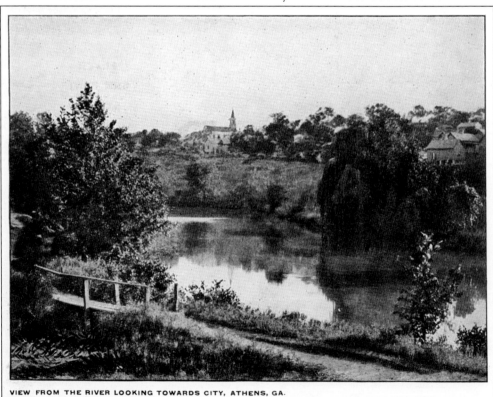

VIEW FROM THE RIVER LOOKING TOWARDS CITY, ATHENS, GA.

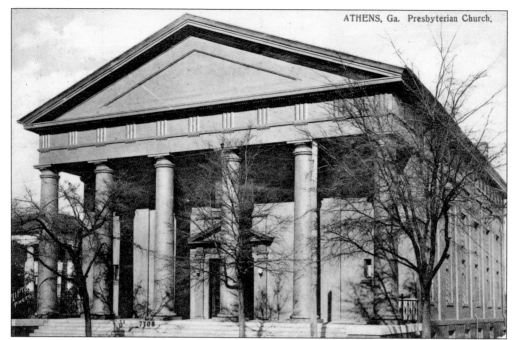

The First Presbyterian Church at 185 East Hancock Avenue was completed by builder Ross Crane at a cost of $10,000 in 1856. This was the church of Confederate brigadier general T.R.R. Cobb, and his funeral was held here after he was killed at the Battle of Fredericksburg in December 1864. The church is still in use by Athens's Presbyterians.

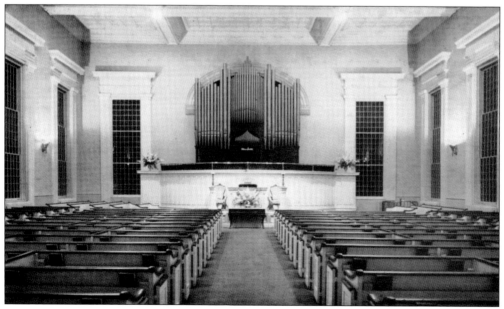

The sanctuary of First Presbyterian Church looks much the same today. The brass nameplates of many of the original members are still attached to the pews they occupied in the middle of the 19th century.

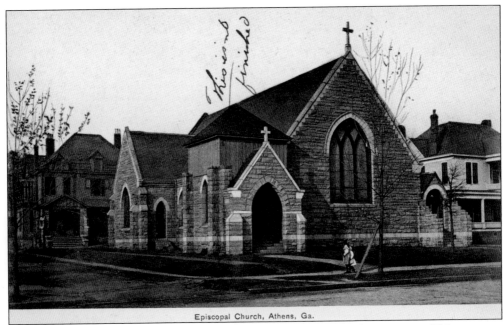

Episcopal Church, Athens, Ga.

The Episcopal Church is located on Prince Avenue at the corner of Pope Street. This structure replaced the old church building put up on the corner of College Avenue and Clayton Street in 1843. The cornerstone of the new church was laid May 13, 1895. The building was essentially completed in 1899, but the tower was not added until 1925.

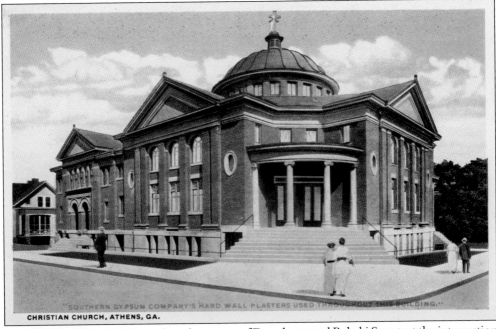

CHRISTIAN CHURCH, ATHENS, GA.

First Christian Church is located on the corner of Dougherty and Pulaski Streets at the intersection with Prince Avenue. The first services were held there on December 19, 1915. This brick building replaced a frame structure across the street that was constructed in 1884. The new church cost more than $50,000 and seats about 600.

Athens Baptist Church, now First
Baptist Church, was completed in 1896
on the corner of Market Street (now
Washington Street) and College Avenue.
It replaced an earlier building completed
on the same site in 1860. In 1921, the
congregation constructed their current
building on the corner of Pulaski Street
and Hancock Avenue, and the structure
shown here was soon demolished.

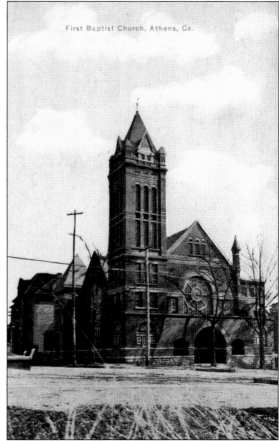

First Baptist Church on the corner of
Pulaski Street and Hancock Avenue sits
on the former site of the Blanton Hill
home. After the death of Hill's widow in
1894, John D. Moss bought the lot, and
the congregation purchased the lot from
Moss in 1916. The first service was held
here on June 12, 1921.

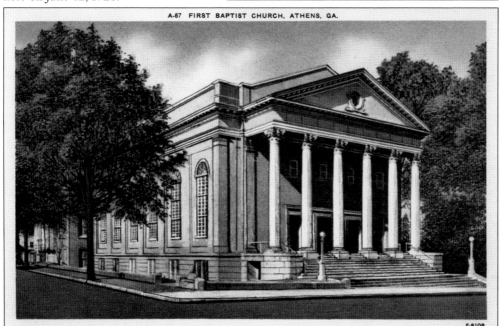

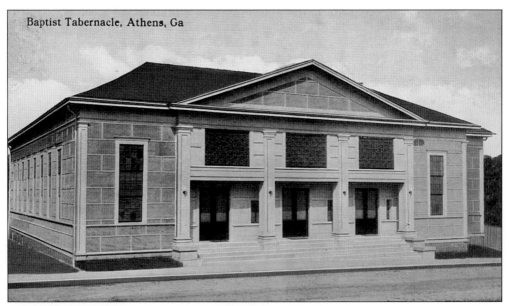

Baptist Tabernacle, Athens, Ga

The Baptist Tabernacle was located on Childs Street across from Childs Street School. The first services were held June 15, 1913, with Pastor R.E. Neighbour officiating. The building stood only six years and was destroyed by fire on April 12, 1919. The congregation met in the Athens High School gymnasium until a new building was completed on Prince Avenue in 1921, and the name was changed to Prince Avenue Baptist Church.

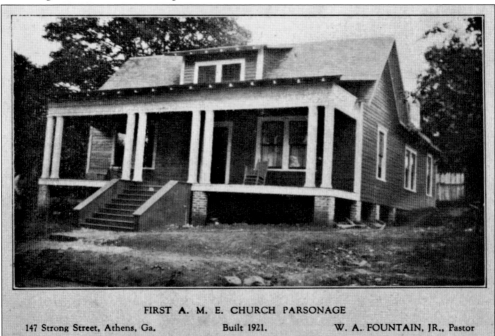

FIRST A. M. E. CHURCH PARSONAGE

147 Strong Street, Athens, Ga. Built 1921. W. A. FOUNTAIN, JR., Pastor

The parsonage of First African Methodist Episcopal Church was built at 147 Strong Street in 1921. During the massive urban renewal that took place in Athens in the early 1960s, the parsonage was demolished and that part of Strong Street where it stood no longer exists. Housing units owned by the church now occupy the site.

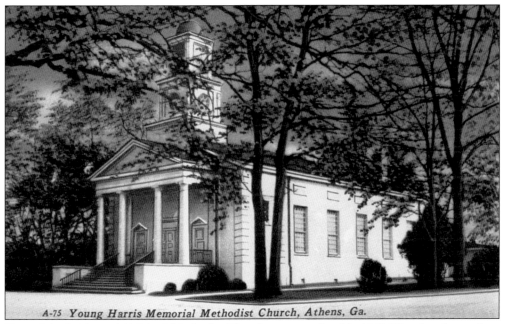

A-75 *Young Harris Memorial Methodist Church, Athens, Ga.*

Young Harris Memorial United Methodist Church was completed in 1949. The church members had bought the E.K. Lumpkin home at 973 Prince Avenue in 1945 and used it until its new building was finished next door. A connection was then built between the church and the house, and the house was remodeled. The church was designed by Clarence Wilmer Heery.

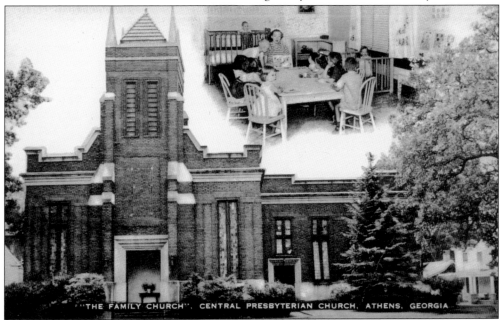

"THE FAMILY CHURCH", CENTRAL PRESBYTERIAN CHURCH, ATHENS, GEORGIA

Central Presbyterian Church, originally named Prince Avenue Presbyterian Church, was established on May 29, 1910, in a house on Prince Avenue. The building shown here was built on the corner of Prince and Milledge Avenues in 1914. The first pastor was Samuel Jackson Cartledge, who served until his death in 1940. As the congregation grew, the church was moved to other locations, and its current home is 380 Alps Road.

The Tuckston Methodist Church building was completed on Highway 78 in eastern Clarke County in 1898. This original structure still stands, but a huge new facility next door now houses the sanctuary, offices, meeting rooms, and a nursery. The 1898 building has been maintained in immaculate condition and is used as a wedding chapel and for youth group activities.

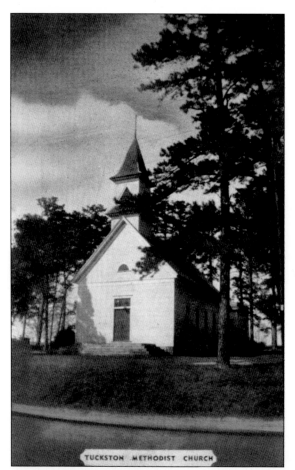

TUCKSTON METHODIST CHURCH

The first meeting of the congregation of Friendship Presbyterian Church was held on Easter Sunday, April 1, 1945, in an old farmhouse on the property of Emma Plunkett and J. Swanton Ivy Sr. on Highway 441 between Athens and Watkinsville. A charter was granted to the church on June 8, 1947, and the congregation continued to meet in the farmhouse until 1952, when the basement of the current sanctuary building was constructed at 8531 North Macon Highway. Services continued in the basement until the sanctuary was completed in 1957.

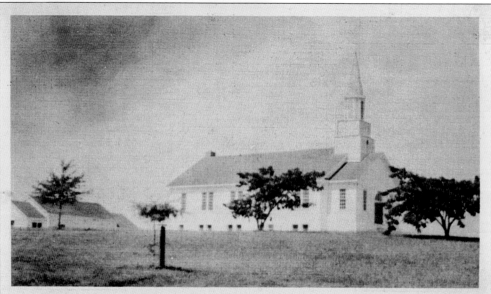

FRIENDSHIP PRESBYTERIAN CHURCH – ROUTE 4 – ATHENS, GEORGIA

Four

US Navy
Pre-Flight School

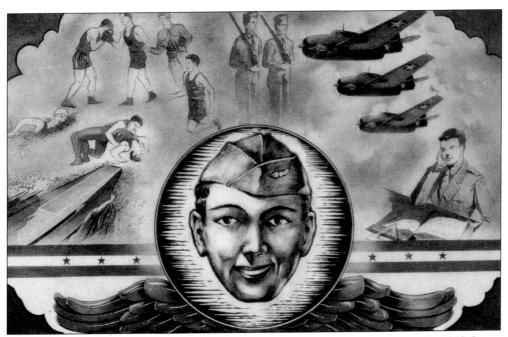

The US Navy established a preflight school on the University of Georgia campus in 1942. It was one of five such schools in the United States. By the end of World War II in 1945, thousands of young aviators had been prepared for service here. In addition to occupying 18 existing buildings on campus, the Navy built three new dormitories, a gymnasium with a large indoor swimming pool, and other facilities.

During their stay at UGA, the Navy gave new names to the 18 buildings they occupied. The original names were reclaimed when the Navy left. Baldwin Hall, shown here, was renamed Operations Center and was used as headquarters for the Navy Pre-Flight School. Baldwin Hall had been built in 1938 as the Demonstration School for the College of Education and named for Abraham Baldwin, the first president of UGA.

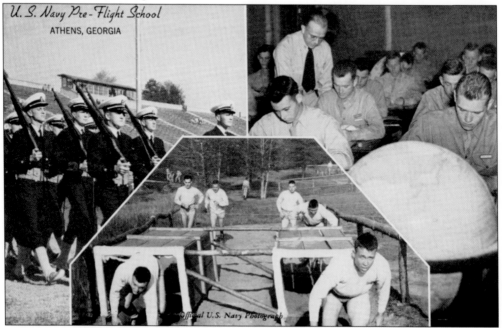

The images on this card portray the daily life of a cadet: drilling, studying, and participating in physical training. In one of the images shown here, cadets are marching on the field at Sanford Stadium in their formal dress blues.

A regulation Navy haircut was required for every pilot trainee. The barber wasted no time with the clippers, and could "process" a cadet in one minute flat.

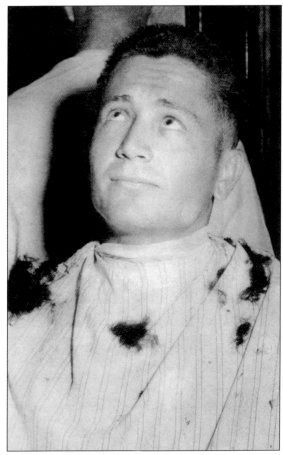

US Navy Pre-Flight School cadets show off their rigid drill training by assembling in formation in front of Wasp Barracks (Milledge Hall). The central part of Milledge Hall was built in 1923 as a dormitory for male UGA students, and additions were completed in 1938. The building currently is used for UGA offices.

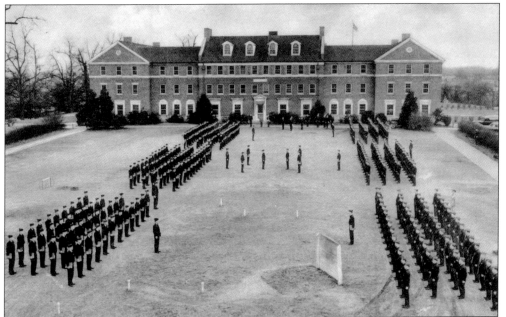

The name of Snelling Dining Hall was changed to John Paul Jones Mess Hall when the US Navy Pre-Flight School occupied the campus. Snelling Dining Hall was built in 1940 to provide nourishing meals for UGA students and faculty. After World War II, it became Snelling Dining Hall once again. Today, it still serves students and faculty.

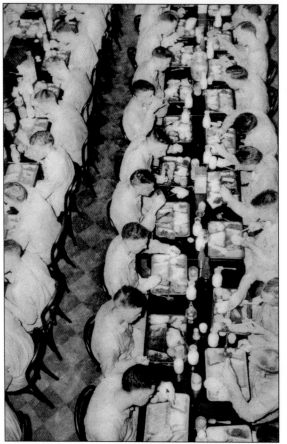

Inside the mess hall, cadets were as disciplined and orderly as when they drilled. To sustain these young men during their vigorous training program, they were fed 5,000 calories a day.

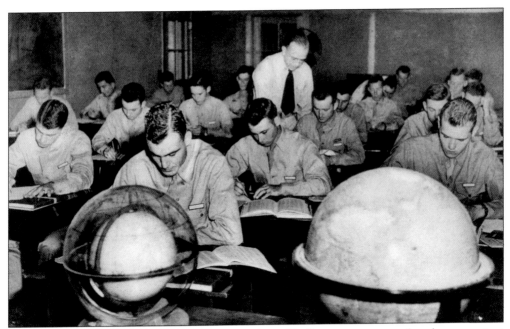

Navigation school also was part of the curriculum. All fliers were expected to be competent navigators. Here is a typical classroom scene as they work out a problem.

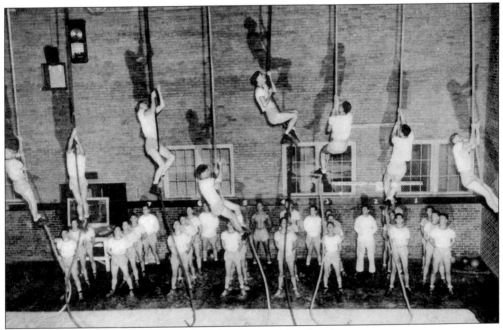

Rope climbing was an important survival skill learned by all cadets.

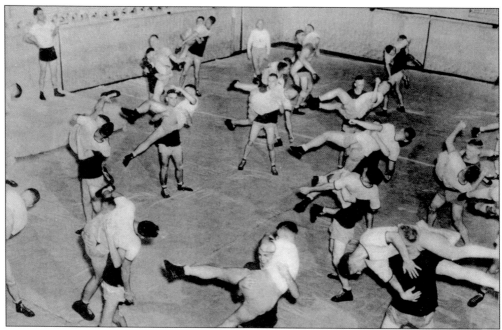

Hand-to-hand combat techniques were taught to all cadets. Physical strength and coordination were developed to a high degree.

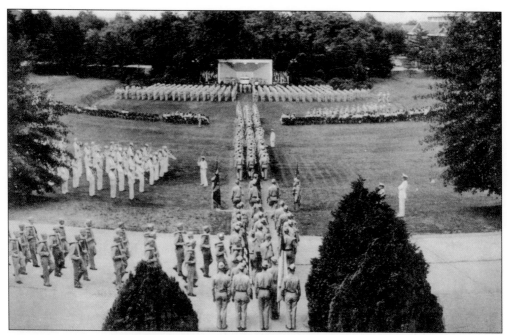

Worship services were held in the amphitheater on Sunday evenings during warm months. The Navy band played as the regiment marched into the amphitheater. The 40-voice cadet choir was seated in the shell in the background.

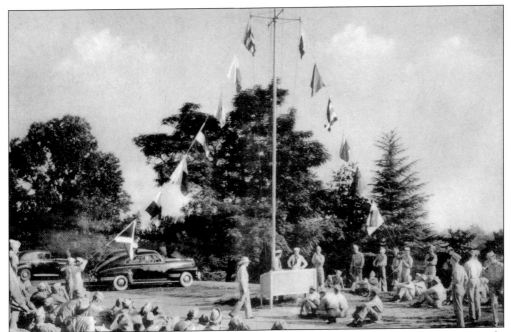

Flag signaling was another mandatory requirement, and instruction in flag signaling was part of a course in communications.

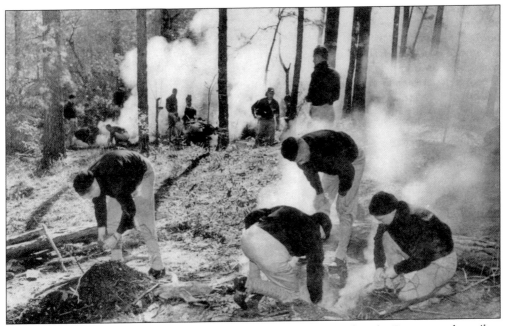

Survival training was an essential part of each cadet's program of study. Future combat pilots learned how to survive in case they were forced down at sea or in some strange land. Training included fire building.

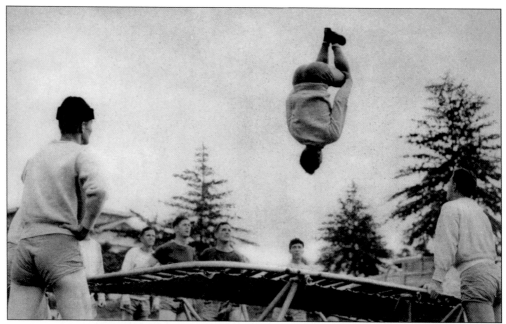

Timing and muscular coordination are essential to combat flyers, and gymnastic stunts on the trampoline were part of the overall physical training for cadets.

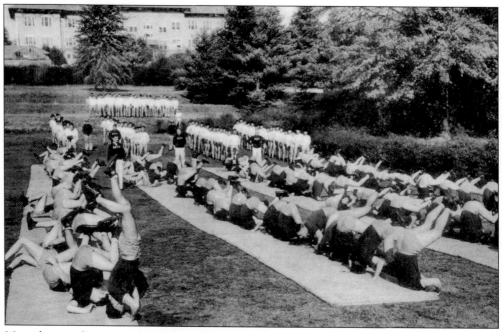

Muscular coordination and endurance were developed in each cadet.

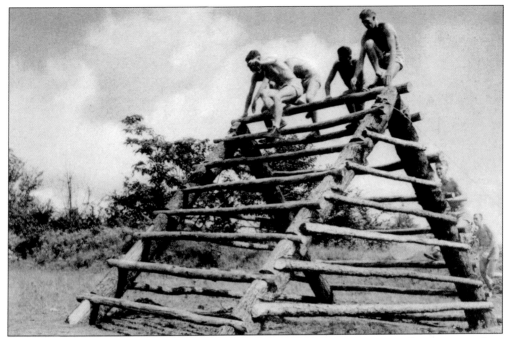

The obstacle course was located behind the present–day College of Veterinary Medicine. Preparations for the tough physical demands of combat flying was an important phase of cadet training at the school, and fledgling aviators built strong muscles going through the obstacle course.

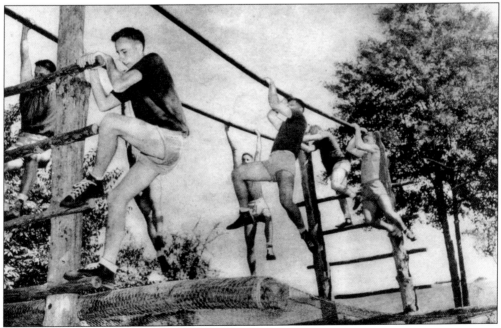

Muscular agility was emphasized in this hand–over–hand obstacle as cadets built physical coordination and stamina as part of their training.

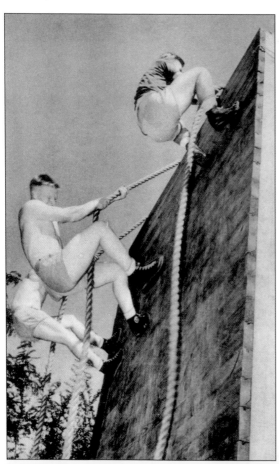

A slick 20-foot wall was one of the many barriers to be mastered on the obstacle course.

As soon as the cadets cleared the 20-foot slick wall, they immediately encountered another obstacle.

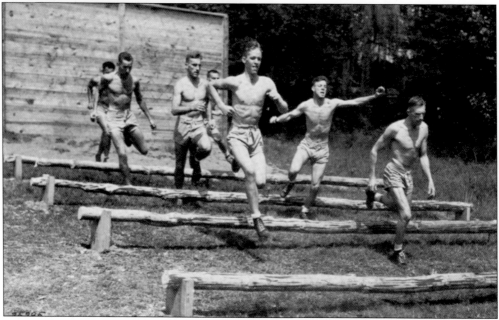

Running through a wooden trough without letting one's feet touch the bottom of the trough required speed, balance, and strength.

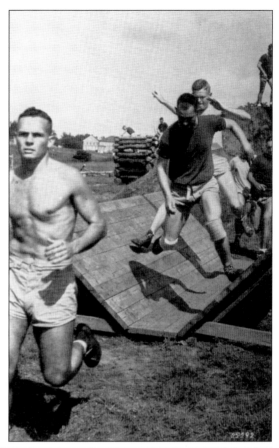

A 28-acre victory farm was maintained by fledgling aviators during summer months. Benefits were twofold: they gained considerable exercise and enjoyed eating the delicious fresh vegetables.

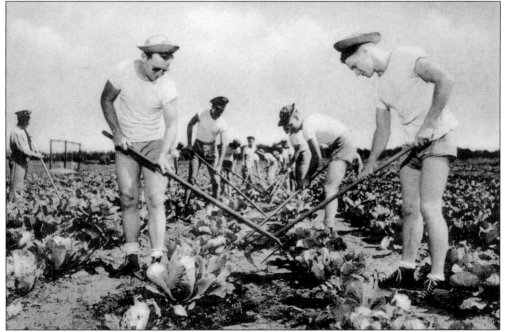

The colors pass in review in a cadet regimental parade.

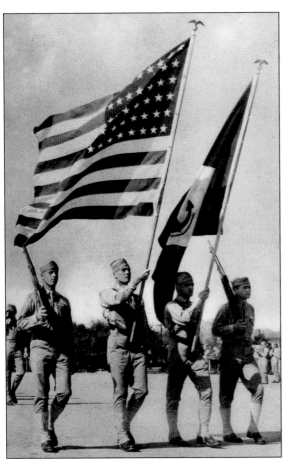

No longer cadets, these men stand at attention at graduation, ready to take on whatever job is necessary to defend their country.

Five

PRIVATE RESIDENCES

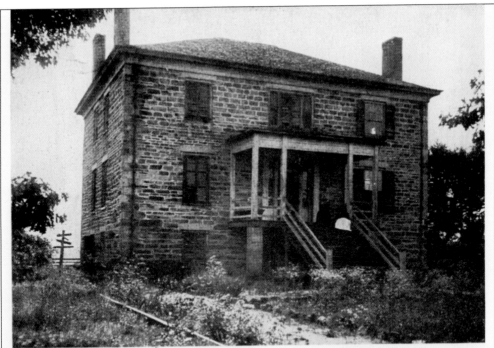

THE OLD HOME OF GOVERNOR WILSON LUMPKIN, ATHENS, GEORGIA
This is the First Structure (not of wood) erected in this city and was built by Stone Masons brought from Scotland to do the work. It is now included in the Extended Campus. McGregor Co. Inc. Pubs., Athens, Ga.

The Wilson Lumpkin House was built by Georgia governor and US senator Wilson Lumpkin, who bought 736 acres on the southern outskirts of Athens for his retirement home. He started this 40-by-52-foot stone house in 1842 and completed it two-and-a-half years later. It was built of local granite dressed on the site. Lumpkin's daughter Martha Compton sold the property to UGA in 1907 with the provision that the house never be demolished.

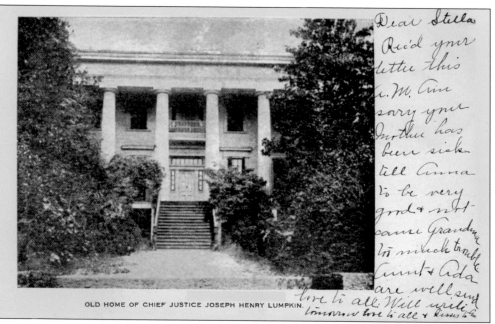

OLD HOME OF CHIEF JUSTICE JOSEPH HENRY LUMPKIN.

Joseph Henry Lumpkin was a younger brother to Gov. Wilson Lumpkin. The younger Lumpkin became the first chief justice of the Georgia Supreme Court and was one of the founders of the Lumpkin School of Law at the University of Georgia. His home was built in the 1830s and still stands at 248 Prince Avenue.

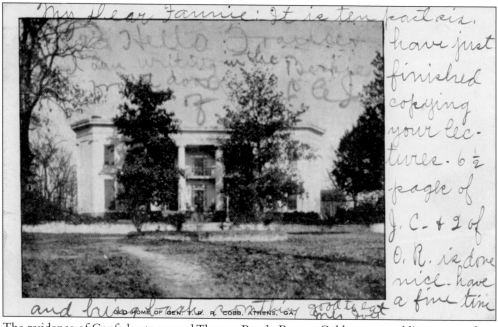

OLD HOME OF GEN. T. R. R. COBB, ATHENS, GA.

The residence of Confederate general Thomas Reade Rootes Cobb was a wedding present from his father-in-law, Judge Joseph Henry Lumpkin, in 1844. To prevent its destruction in 1985, the house was moved to Stone Mountain Memorial Park where it was to be restored. However, it languished there untouched for 20 years until the Watson-Brown Foundation moved the house back to Athens and restored it as a house museum.

82

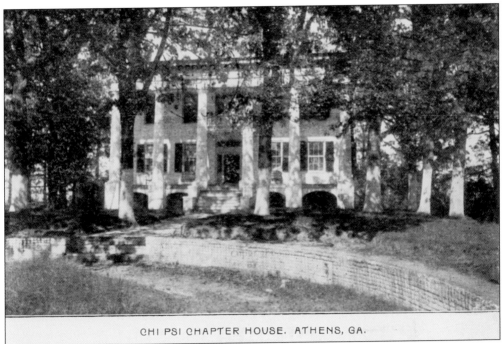

CHI PSI CHAPTER HOUSE, ATHENS, GA.

Howell Cobb Sr. married Mary Ann Lamar in 1835 and built this three-story Greek Revival house at 498 North Pope Street, one block from Prince Avenue. It was built of cement-covered brick. The Cobbs lost the house because of the nationwide financial crisis in 1838. When this postcard was made in 1907, the home was rented to the Chi Psi fraternity.

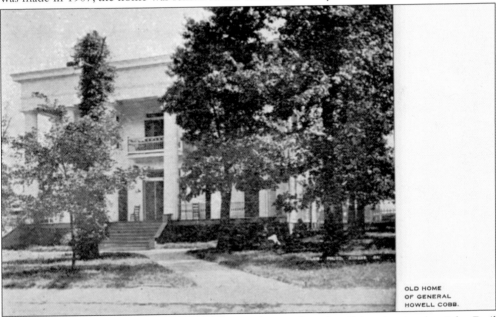

OLD HOME
OF GENERAL
HOWELL COBB.

Mary Ann Lamar Cobb inherited a considerable fortune from her father; her brother John Basil Lamar was the trustee of her property. In 1850, Lamar had this house built for the Cobbs on a large lot at 425 Hill Street. Howell Cobb Sr. died in 1868. After Mary Ann's death in 1889, the house was moved to the front of the lot and the lot was divided into five additional lots.

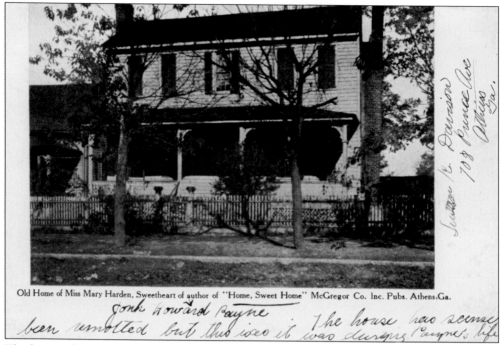

Old Home of Miss Mary Harden, Sweetheart of author of "Home, Sweet Home" McGregor Co. Inc. Pubs. Athens,Ga.

John Howard Payne

been remolded but this idea it was during Payne's life. The house has sence

The home of Gen. Edward Harden and his wife, Mary Ann Randolph Harden, was built on the north side of Hancock between Hull and Pulaski Streets before 1835. According to local legend, Harden's daughter Mary Elisa Greenhill Harden was a sweetheart of John Howard Payne, author of *Home, Sweet Home.*

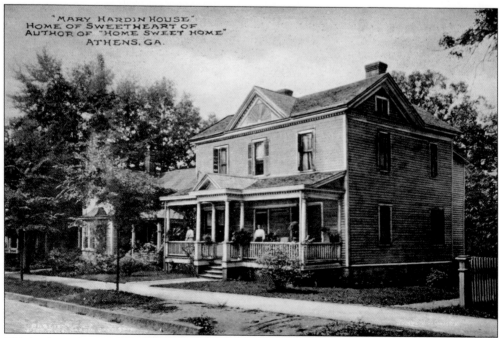

This is a later view of the Harden House after extensive renovations drastically changed its outward appearance. The house was demolished about 1949.

Henry Woodfin Grady was born in this four-room cottage on the corner of Hoyt and Jackson Streets on May 24, 1850. Grady graduated from UGA in 1868 and was a journalist for several newspapers before becoming managing editor and one-fourth owner of the *Atlanta Constitution*. The house was demolished in the mid-1950s, and the site is now a parking lot.

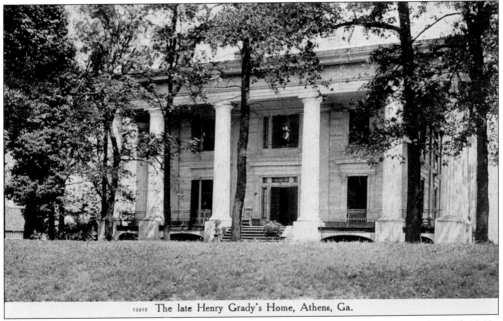

13312 The late Henry Grady's Home, Athens, Ga.

The Taylor–Grady House was built at 640 Prince Avenue by Gen. Robert Taylor in the mid-1840s. In 1863, William Sammons Grady, the father of Henry W. Grady, bought the house. The senior Grady was killed the next year during the War Between the States. Henry W. Grady lived here only a short time while attending the University of Georgia, but his later fame has forever attached his name to the house.

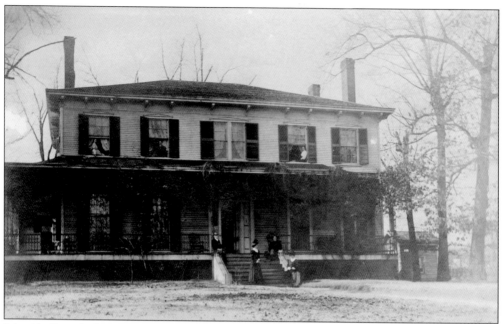

John Ferdinand Phinizy built this house at 325 Milledge Avenue in 1857 and sold it two years later. Other owners occupied the house until it was bought by Dr. John Atkinson Hunnicut and his wife, Mary, in 1873. Members of the Hunnicut family owned the house for 113 years until it was sold in 1986. It still stands and is currently used as office space.

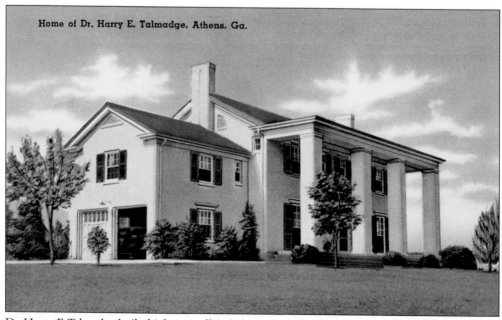

Dr. Harry E. Talmadge built this house off Oglethorpe Avenue, then known as Old Atlanta Highway or Old Mitchell Bridge Road in 1940 or 1941. The exterior of the house is a replica of the famed Tara in *Gone With the Wind*. He named his home Tip Top, and the road leading to it became Tip Top Road, now named Forest Heights Drive. Tip Top still stands at 442 Forest Heights Drive.

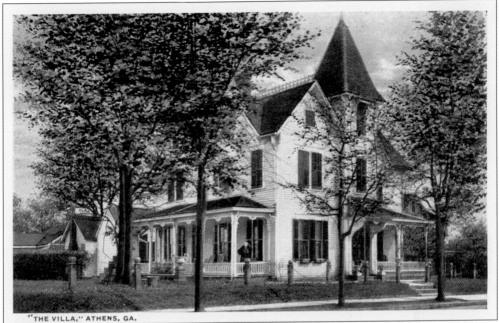

"THE VILLA," ATHENS, GA.

The Villa stood across Milledge Avenue from Lucy Cobb Institute. It was the home of Mildred Lewis Rutherford, who taught at Lucy Cobb for many years and was principal until she stepped down in 1895 to be replaced by her sister Mary Ann. The Villa was destroyed by fire on December 25, 1927.

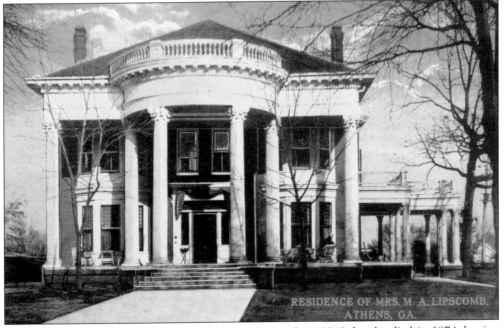

RESIDENCE OF MRS. M. A. LIPSCOMB, ATHENS, GA.

Mary Ann Rutherford married Francis Adgate Lipscomb in 1869, but he died in 1874, leaving her with three small children. Mary Ann began teaching school at Lucy Cobb Institute in 1880 and succeeded her sister as principal in 1895, a position she held until her retirement in 1907. She continued to live in this home at 285 South Milledge Avenue until her death in 1918.

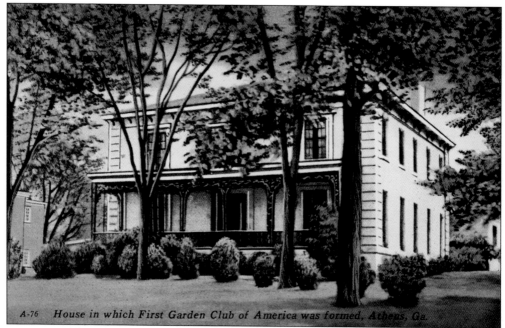

A-76 House in which First Garden Club of America was formed, Athens, Ga.

Robert Galphin Twiggs Taylor began construction on this house at 973 Prince Avenue in 1857, but he died before the house was completed in 1858. Edwin King Lumpkin bought this house in 1884. Lumpkin's wife, Mary Bryan Thomas Lumpkin, and 11 of her neighbors met here in 1891 to form the first ladies' garden club in the United States. Originally called the Cobbham Garden Club, the name was changed in 1892 to the Ladies' Garden Club.

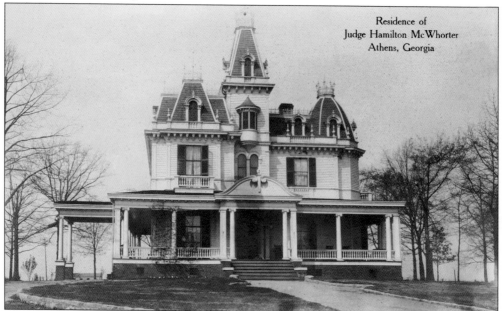

Residence of
Judge Hamilton McWhorter
Athens, Georgia

Dr. Henry Hull Carlton built this beautiful mansion on what is now Cloverhurst Avenue in 1885. Judge Hamilton McWhorter bought the house in 1901 when he moved his family to Athens from Lexington. The house was demolished in 1929, and the surrounding property was subdivided and sold.

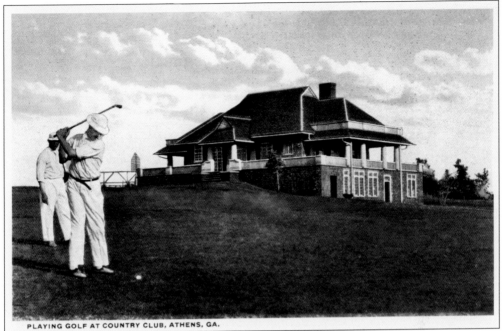

PLAYING GOLF AT COUNTRY CLUB, ATHENS, GA.

Cloverhurst Country Club was started in 1910 adjacent to the Carlton–McWhorter House property. The clubhouse seen here was located on what is now Fortson Drive. The club closed during the Great Depression in the 1930s, and the property was sold for residential lots. The clubhouse was converted to a private residence, but it has since been replaced with a modern house.

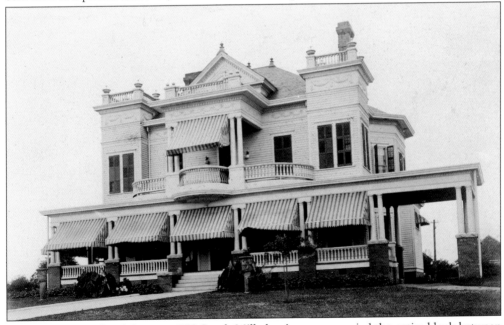

Dr. William A. Carlton's home at 750 South Milledge Avenue occupied the entire block between Cloverhurst Avenue and Springdale Street. The house was demolished around 1961, and an apartment building was put on the site. The University of Georgia later bought the property, and the apartment building became Kappa Delta sorority.

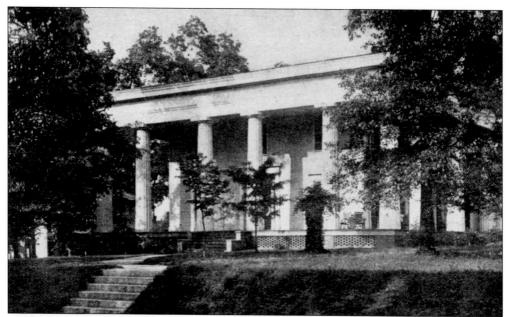

This house was built on the corner of Milledge Avenue and Dearing Street in 1856 for Eliza Pasteur Dearing, the recently widowed mother of Albin Pasteur Dearing. The house originally faced Dearing Street but was turned to face Milledge Avenue. In 1886, the house was bought by Augustus Longstreet Hull, who was married to T.R.R. Cobb's daughter Callie. The house was demolished in 1965 to make way for an office building.

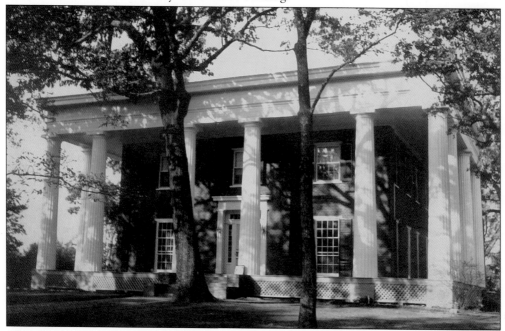

Albin Pasteur Dearing and his wife, Eugenia, built this house at 338 South Milledge Avenue in 1858, almost across the street from his mother's house. Its most unusual feature is that it was built of brick when most houses in Athens at this time were of frame construction. The Dearing family sold the house to Kappa Alpha Theta sorority in 1938. It has been maintained in immaculate condition.

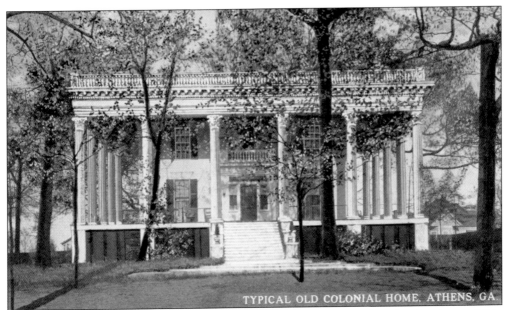

This house was built at 387 South Milledge Avenue by Alfred Long Dearing, brother to Albin Pasteur Dearing. Construction began in 1860 and was completed in 1865. The house was bought by Jessie Stanley Horton Wilkins in 1909, and she and her husband, John Julian Wilkins, added the Classic Revival porch with 14 columns. The Wilkins family has generously supported the University of Georgia. Members of the Wilkins family still own the house.

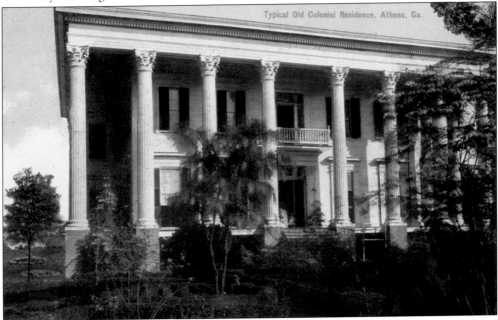

This magnificent Greek Revival mansion at 570 Prince Avenue was completed in 1858 by John Thomas Grant. The house was successively owned by US senator Benjamin Harvey Hill, Hill's son Charles Dougherty Hill, James White, and others before it was purchased by the Bradley Foundation of Columbus, Georgia, in 1949 and donated to the University of Georgia for use as the residence of the president of the university.

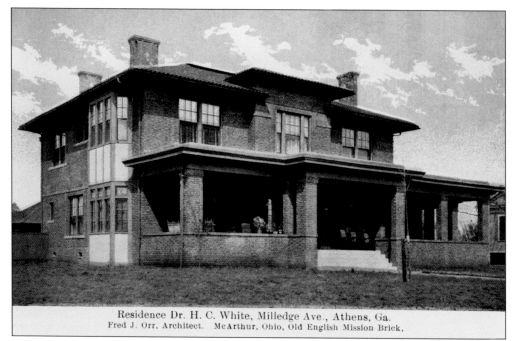

Residence Dr. H. C. White, Milledge Ave., Athens, Ga.
Fred J. Orr, Architect. McArthur, Ohio, Old English Mission Brick,

The home of Dr. Henry Clay White and his wife, Ella, stood at 624 South Milledge Avenue. Dr. White came to the University of Georgia in 1872 as head of the chemistry department and held this position for 55 years until his death in 1927, a month short of his 79th birthday. The house burned in 1967, and an office building occupies the site.

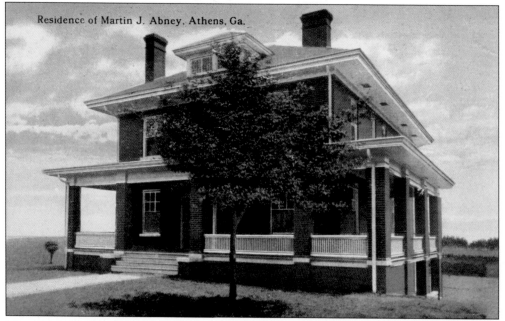

Residence of Martin J. Abney, Athens, Ga.

The Martin J. Abney house was built around 1915 at 765 South Milledge Avenue between Cloverhurst Avenue and Springdale Street. In the 1950s, the Alpha Gamma Rho fraternity house was built next door, and when the fraternity was enlarged in the 1960s, the Abney house was incorporated into the addition.

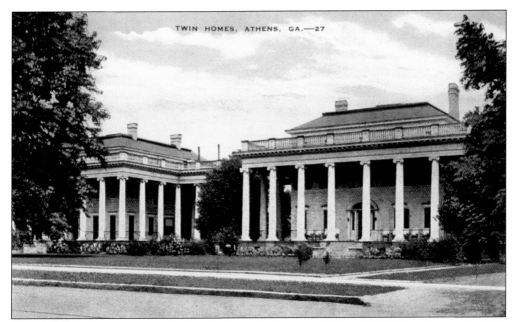

TWIN HOMES, ATHENS, GA.—27

Brothers Simon and Moses Michael built these twin homes at 596 and 598 Prince Avenue in 1902. The neoclassical houses were connected by a colonnade and located between the Taylor-Grady House and the University of Georgia president's house. Both of the Michael brothers' homes were demolished in the 1960s, and small brick office buildings now occupy the site.

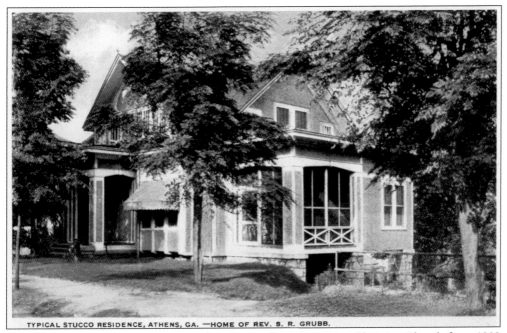

TYPICAL STUCCO RESIDENCE, ATHENS, GA. —HOME OF REV. S. R. GRUBB.

Rev. Stanley Robert Grubb served as the minister for Athens First Christian Church from 1909 to 1921 and from 1926 to 1936. Grubb and his wife, Mable, lived at 490 Pulaski Street, next door to the church. The church bought the property in 1985 and leases it rent free to Athens-Clarke County for use as the Athens Attention Home, a temporary home for troubled children.

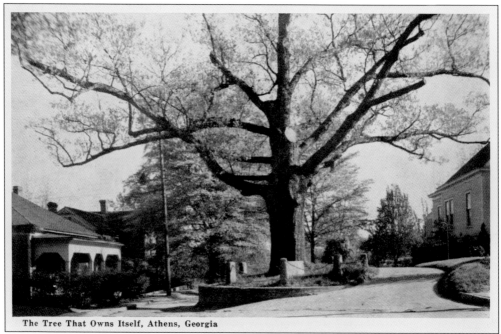

The Tree That Owns Itself, Athens, Georgia

"The Tree That Owns Itself" supposedly was so loved by UGA professor William Henry Jackson that he gave ownership of the tree and the land around it to the tree itself. This popular myth probably was created by Athens newspaper editor T. Larry Gant. Although no such deed is recorded in the Athens–Clarke County Courthouse, Athens residents have respected the tree's ownership and enjoy showing it off to visitors.

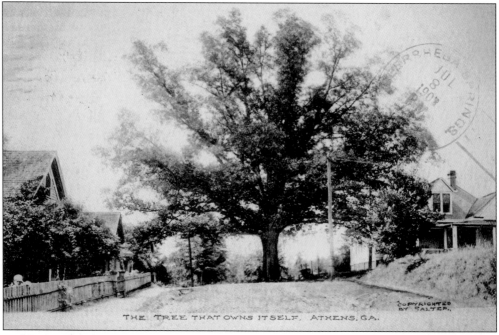

THE TREE THAT OWNS ITSELF, ATHENS, GA.

In this view, the tree is pictured after UGA benefactor George Foster Peabody paid to have the lot enclosed with a chain and a monument put in place at the base.

THE ONLY TREE IN THE WORLD THAT OWNS ITSELF, ATHENS, GA.

TO THE TREE THAT OWNS ITSELF

Oh, you great big wonderful tree, so grand,
 Standing on soil of your own,
With your limbs outstretched to Heaven above,
 Growing there all so alone;
We do bow to you, a Monarch of old,
 Homage is surely your due,
You stand alone in the hist'ry of trees,
 With a record that is new.

"Oh, touch not a single bough" it was said,
 By a Poet in his song,
And the man who loved you in days gone by
 Took thought that you might live long.
For you are a tree, which owns itself,
 And the ground on which you stand,
And as you have lived for centuries, now
 You're safe from the Vandal's hand.

For a hundred of years and more ago,
 A Lover of Nature true,
Who'd cherished and cared for you many years,
 (Owned the land on which you grew),
Left a clause in his Will, that said "This Tree
 And the land for eight feet round,
Shall belong to Itself for evermore";
 So you own yourself and ground.

So you great big beautiful tree, so tall,
 Waving your boughs in the breeze,
With your roots deep down in old Georgia's soil,
 A Giant among all the trees;
We all wish for you, a very long life,
 And hope the winds may be kind,
That your life may be spared for many years,
 To live for man's love enshrined.

EDWIN B. MAGILL

Numerous postcard views of "The Tree That Owns Itself" were published from about 1905 to the 1920s. This three-section card shows the tree and a four-stanza poem written by Edwin B. Magill of Toledo, Ohio.

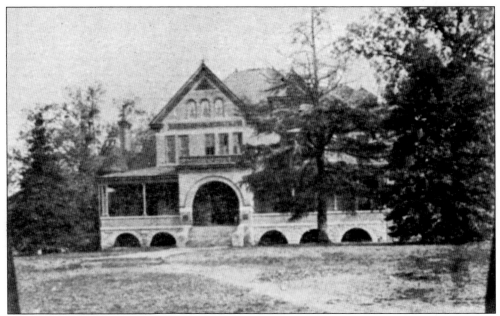

In 1891, Whitehall Mansion was built for the John Richards White family in Whitehall at the end of Milledge Avenue. White was the owner of Georgia Factory, an early successful cotton factory. The home still stands, and the property is owned by the University of Georgia's Daniel B. Warnell School of Forestry Resources.

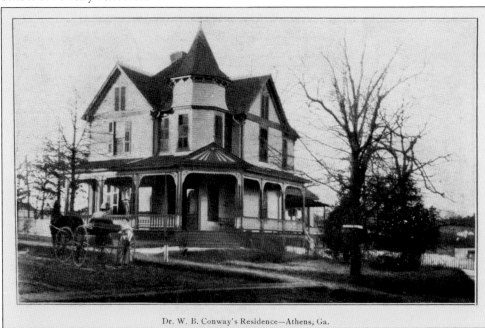

Dr. W. B. Conway's Residence—Athens, Ga.

Dr. William Buchanan Conway was born in Virginia, and during the War Between the States, he served in the Confederate army in Company C, 4th Virginia Cavalry. Dr. Conway moved to Athens in 1891 and operated a drugstore before opening a medical practice. In 1899, he bought this house on the corner of Nantahala Avenue and Wynburn Place. Dr. Conway moved back to Virginia in 1916 and died there in 1920. This house is no longer standing. (Courtesy of Patrick Mizelle.)

Six

BUSINESS AND INDUSTRY

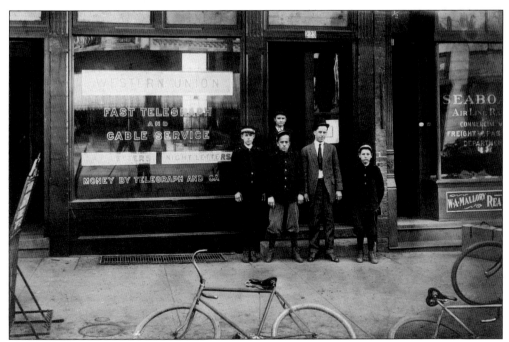

When this picture was made about 1910, the Western Union Office was located on Clayton Street near the corner of College Avenue. The manager, T.H. Gore, and the delivery boys are seen here posing out front. The offices of the Seaboard Air Line Railway and realtor W.A. Mallory were next door. The young boy on the right was James Edward Spinks, a lifelong resident of Athens.

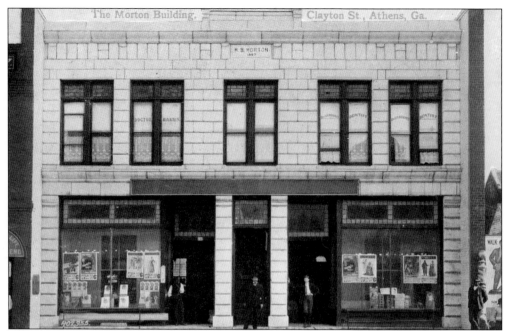

Monroe Bowers "Pink" Morton was an Athens entrepreneur who constructed several buildings in Athens in the early 1900s. This office building, located at 146 Clayton Street and constructed in 1907, was home to several African American businesses, including a doctor, dentist, insurance agency, barbershop, and two newspapers. His only white tenant was Bennett and Bacon's Billiard and Pool Hall.

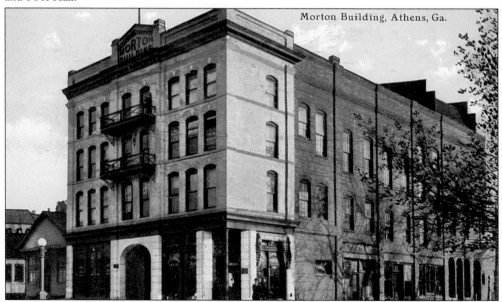

Pink Morton is best known for his Morton Theater, a black vaudeville theater, at the corner of Washington and Hull Streets that was built in 1910. In addition to the theater, the three-story structure also was home to several African American businesses, some of who had been his tenants in his Clayton Street office building. An especially prominent tenant was Dr. Blanch Thompson, the first African American female physician in Athens.

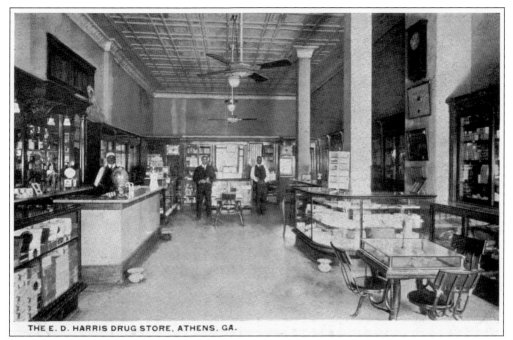

THE E. D. HARRIS DRUG STORE, ATHENS, GA.

Dr. Ellington D. Harris, another tenant of Pink Morton, operated the first black drugstore in Athens in the Morton Theater building in 1910. Other owners of the drugstore were William H. Harris, C.S. Haynes, and B.B.S. Thompson.

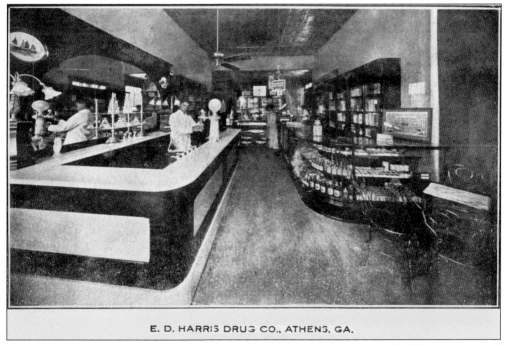

E. D. HARRIS DRUG CO., ATHENS, GA.

The E.D. Harris Drug Store soon moved into the nearby Good Samaritan Building, also owned by Pink Morton, and continued to operate for many years. The Good Samaritan Building was demolished in the early 1970s.

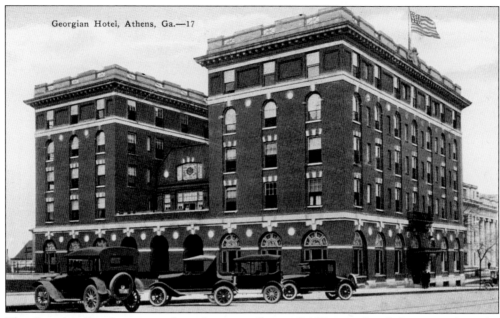

Georgian Hotel, Athens, Ga.—17

The Georgian Hotel was a modern, five-story, fireproof, 112-room hotel that opened on the corner of Washington and Jackson Streets in March 1909. It was as fine and grand as any hotel could be at the time. All but about a dozen rooms had private baths.

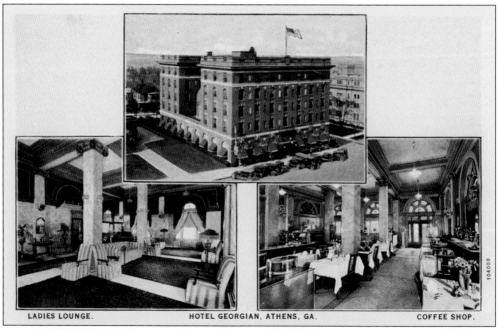

LADIES LOUNGE.　　　HOTEL GEORGIAN, ATHENS, GA.　　　COFFEE SHOP.

This attractive composite view of the Georgian Hotel shows some of the splendor for which it was known. The huge building spanned 100 feet on the Washington Street front and was 130 feet long on the Jackson Street side.

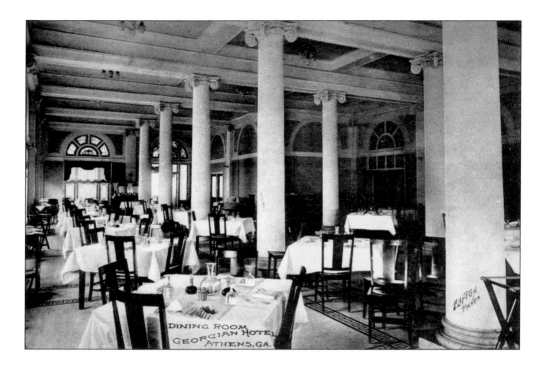

The Georgian Hotel Dining Room and Reading Room display some of the elegance of the hotel with its magnificent tile floors and stunning marble walls and columns. The Georgian was remodeled and converted into private apartments in the 1980s.

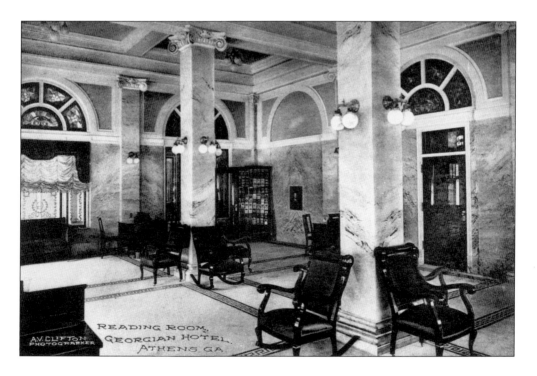

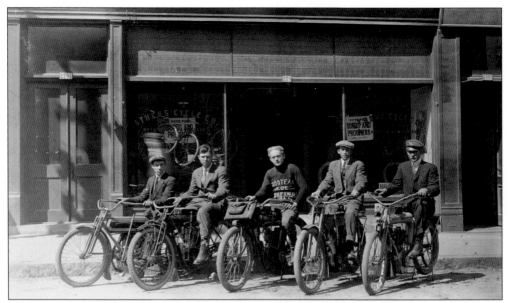

The Athens Cycle Company operated at two successive locations on Lumpkin Street. The first was at 279 North Lumpkin. The business was owned by Francis P. Griffeth and Alvin A. Jones, who advertised that they were dealers in bicycles and sewing machines. It is quite evident that they also dealt in motorcycles. The first location was demolished in the 1980s by Bank of America for a parking lot and drive-through bank outlet. A large multiuse commercial building is under construction on the site.

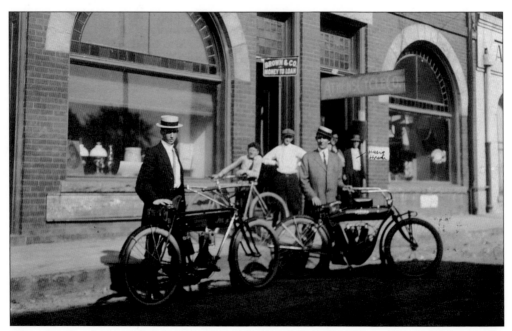

The other location was across the road at 264 North Lumpkin Street. This building was the location of the *Athens Observer* for many years and still stands today.

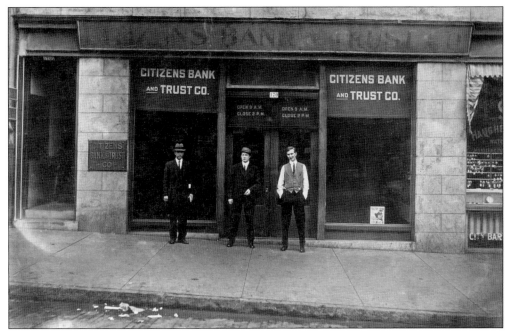

The Citizens Bank and Trust Company was first located at 197 East Clayton Street when it opened on January 3, 1907. When this postcard was produced in 1910, the bank had relocated to 170 College Avenue.

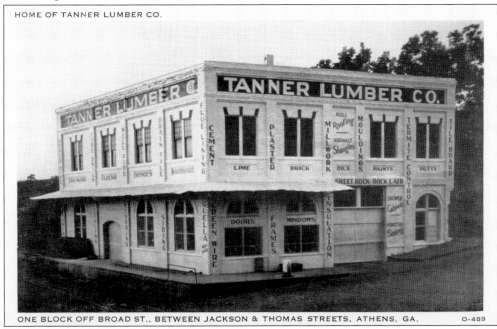

Tanner Lumber Company was originally Carter-Moss Lumber Company, then the Dozier Company. The building shown here was constructed in 1909. In 1928, Johnnie Bryson Tanner Sr. began working here, and in 1947, he bought the business. Tanner's older son, J. Bryson Tanner Jr., later joined his father in the business, and they continued to operate until the death of the elder Tanner in 1995. In 1996, the property was sold to UGA. (Courtesy of J. Bryson Tanner Jr.)

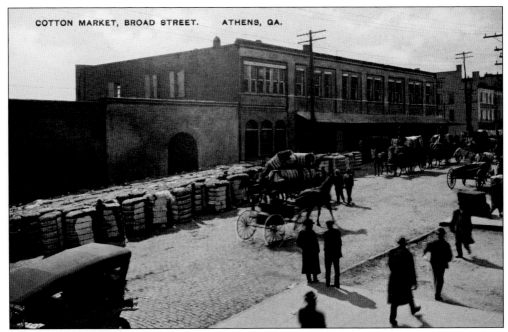

The triangular building at the intersection of Broad and Oconee Streets was constructed by Billups Phinizy in 1897. The front of the building housed a wholesale-retail grocery store, and the rear of the building was used by Phinizy as a cotton warehouse. Benjamin B. Meyer bought the building in the 1930s and opened Farmers Hardware. In recent years, the building was converted to apartments. This is a side view of the cotton warehouse from East Broad Street about 1915, showing the overflow of cotton stored in the street.

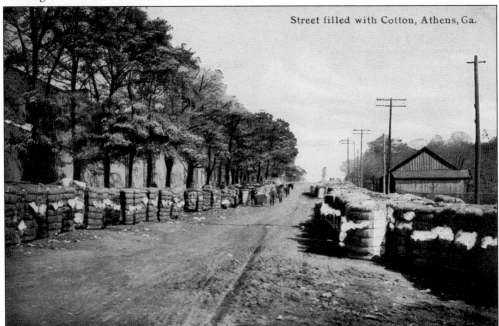

By the end of the cotton season in a good year, the warehouses could not hold all that was produced, resulting in surplus bales of cotton commonly lining the streets of many southern towns.

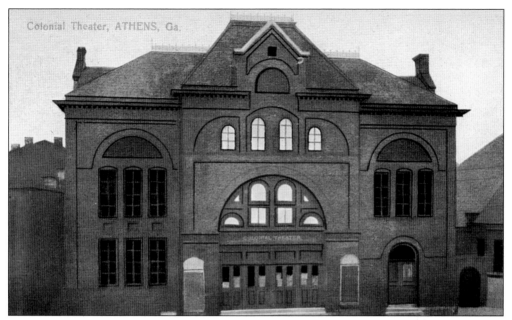

Athens New Opera House opened in January 1888 and was the center of Athens entertainment until the 1920s. Many famous vaudeville acts and minstrel shows performed there, and concerts and silent movies were regular attractions. It could seat 1,006 patrons. In 1905, the Athens New Opera House was remodeled and renamed Colonial Theater. Modern movie theaters eventually put the Colonial out of business, and the building was demolished in 1932.

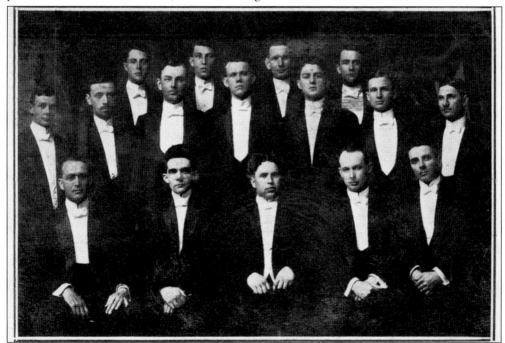

The Athens YMCA Glee Club performed at the Colonial Theater in 1911. A.I. Ruby was the conductor. John Griffith was president of the club, and Arthur Booth was treasurer. Constance Miller was the pianist, and J.L. Morris played the cornet.

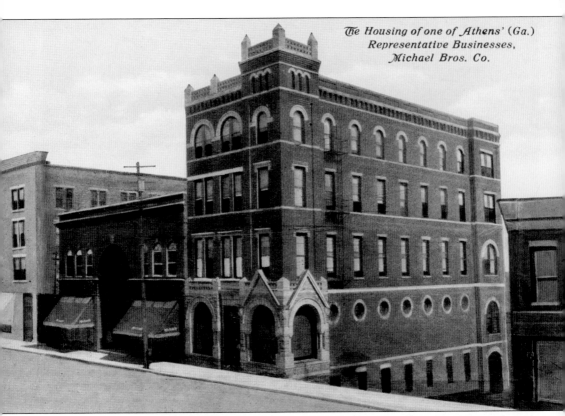

The Housing of one of Athens' (Ga.)
Representative Businesses,
Michael Bros. Co.

In 1882, brothers Simon and Moses G. Michael started Michael Brothers Department Store in part of a small store on the corner of Broad and Jackson Streets known as Bishop's Corner. Their business grew, and in 1885, they took over the entire two-story building. Their dry goods business continued to prosper, and they soon outgrew their space again. Consequently, in 1890, they demolished the frame structure they occupied and erected a new three-story brick building on the same site. They temporarily relocated down the street in the Athens Hardware building while their new shop was under construction. The Michael Brothers Department Store's new building also proved to be too small, and in 1892, they constructed this magnificent five-story structure on the corner of Clayton and Jackson Streets. At that time, this was the tallest building in Athens. Competitors predicted that the business would fail because "it would be impossible to sell enough merchandise in all of Athens to fill that large a store."

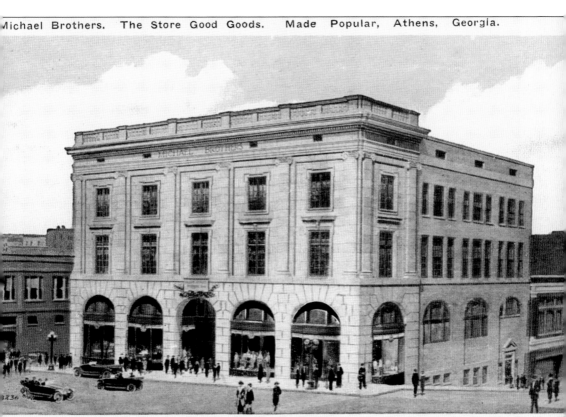

The Michael Brothers Department Store building and many other structures on the block were destroyed by fire on the night of January 24, 1921. The brothers wasted no time in clearing the site and erecting this new building, which was completed in 1923. Their motto, "The Store Good Goods Made Popular," was well known throughout northeast Georgia. Davison-Paxon Company bought the business in 1953 and operated Davison Department Store there until they relocated to Georgia Square Mall in 1981. The Michael family sold the building to investors who renamed it Park Plaza.

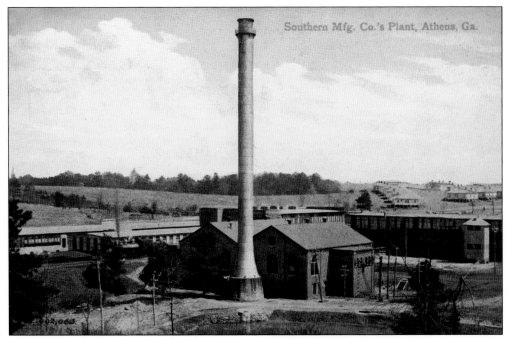

The Southern Manufacturing Company was located along the railroad tracks two blocks north of Boulevard. The company was chartered in 1902 and soon became the second largest cotton mill in northeast Georgia, second only to the Pacolet Manufacturing Company in Gainesville.

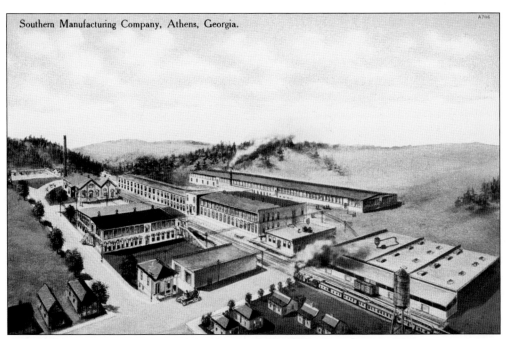

Some of the workers' homes built by the Southern Manufacturing Company are seen here. Although the mill has been closed for many years, some of the buildings still stand, as well as many of the houses.

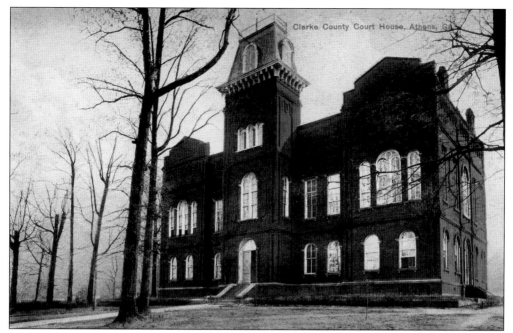

The Clarke County Courthouse was erected on Prince Avenue in 1876 and served until the new courthouse was completed on Washington Street in 1913. The old courthouse building was sold to the city and used as Athens High School until 1952.

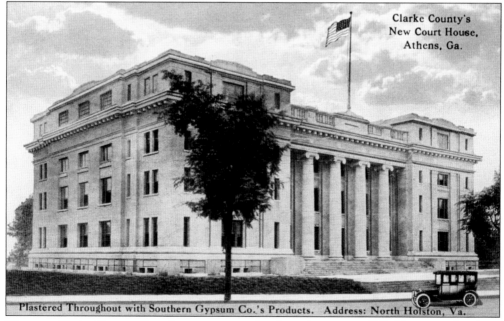

The new Clarke County Courthouse was completed on the corner of Washington and Jackson Streets in 1913. The building site formerly was occupied by C.A. Tucker's blacksmith shop. The building, which has been remodeled and considerably enlarged over the years, still serves the citizens of Clarke County.

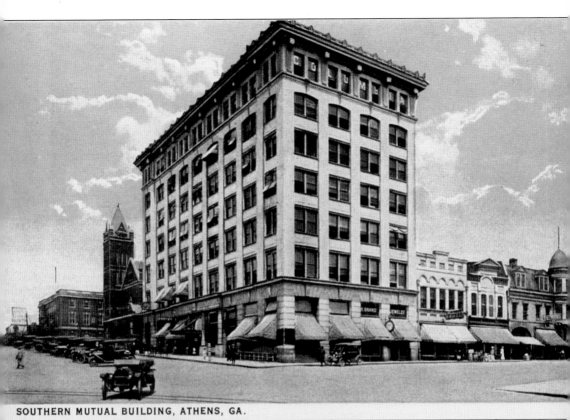

SOUTHERN MUTUAL BUILDING, ATHENS, GA.

The old Southern Mutual Building was erected on the corner of College Avenue and Clayton Street by the Southern Mutual Life Insurance Company in 1876. In 1907, the old Southern Mutual Building was dismantled and rebuilt two blocks north on the corner of College and Hancock Avenues, diagonally across from city hall. The Athens Railway and Electric Company, the forerunner of the Georgia Power Company, was headquartered here. The building was demolished in the 1960s during a vigorous urban renewal program in Athens. The new Southern Mutual Building was completed on the corner of College Avenue and Clayton Street in 1908. This modern seven-story skyscraper was Athens's tallest building until the nine-story Holman Building was completed in 1913. For many years, most Athens doctors, dentists, and lawyers maintained offices in the Southern Mutual Building.

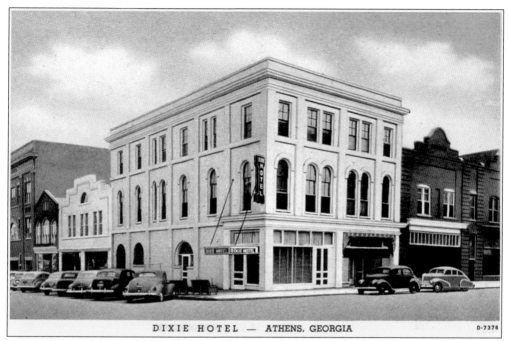

DIXIE HOTEL — ATHENS, GEORGIA D-7378

The Dixie Hotel opened in the 1930s at 304 East Washington Street by the corner of Jackson Street. "Modern–Clean–Comfortable. Why Pay More for Less. Single room from $1.25, Double room from $1.75" is what the hotel advertised. In the late 1950s, the hotel was owned by Compton O. "Fat" Baker, a well-known Athens lawyer and Georgia state representative. The law firm Cook, Noell, Tolley, Bates & Michael, LLP now occupies the building.

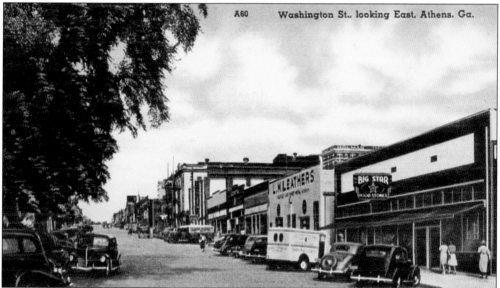

A60 Washington St., looking East, Athens, Ga.

The Big Star Grocery Store building on the corner of Washington and Pulaski Streets is now the home of the world-famous 40 Watt Club and Pain and Wonder Tattoo Studio. Next door was L.M. Leathers Company, established in Winder by Leonidus Milton Leathers in 1901. The company relocated to Athens in 1910 and erected this building in the early 1920s. The business later was renamed L.M. Leathers' Sons.

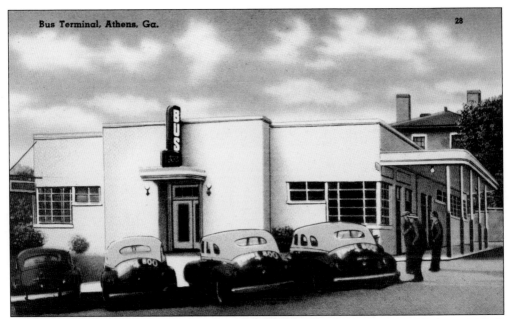

Union Bus Station opened in the late 1920s at 198 East Clayton Street. By the late 1930s, it was headquartered at 170 College Avenue. By 1940, this new building had been erected at 220 West Broad Street by the corner of Hull Street. Five bus lines operated there. The facility now operates under the name Athens Bus Station, and a single bus line, Southeastern Stages, provides bus service.

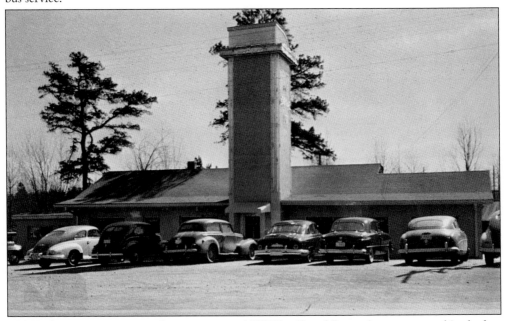

The Pig Drive Inn was a popular restaurant at 1855 West Broad Street that was opened in the late 1940s by James W. Collins and T. Lawrence Collins Jr. The eatery soon was acquired by John S. Bradley, who ran it in the 1950s and 1960s. The restaurant featured curb service or inside dining and was known for fine food. The building has housed a variety of businesses over the years and still stands today.

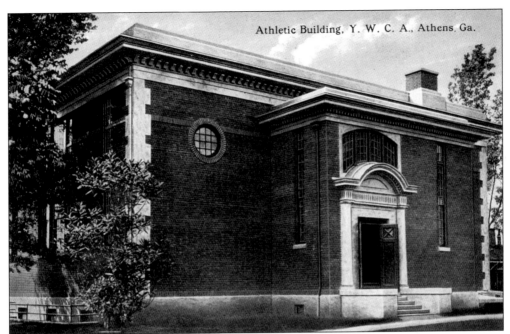

Athletic Building, Y. W. C. A., Athens, Ga.

The YMCA building was erected on the corner of Lumpkin and Clayton Streets in 1889. Around 1920, the upper part of the building was demolished, and the Elite Theater was constructed on the foundation. The Elite later was renamed the Georgia Theater and became an Athens icon. The Georgia Theater was almost totally destroyed by fire in the summer of 2009 but is being rebuilt. It is scheduled to reopen in late 2011.

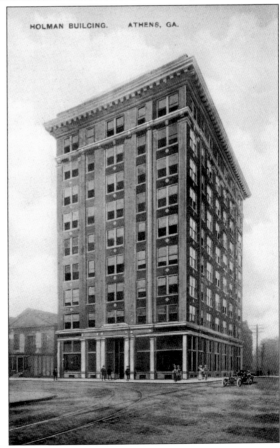

HOLMAN BUILCING. ATHENS, GA.

William Shrewsbury Holman constructed a nine-story office building on the corner of Clayton and Lumpkin Streets in 1913. It was unsuccessful as an office building and soon was converted into a hotel. It was renovated in the early 1960s as the new home of Citizens & Southern Bank, now Bank of America. It remains the tallest building in downtown Athens.

The Old Colony Motor Inn was one of Athens's original motels that opened in the early 1950s, long before Holiday Inn and dozens of other motel franchises became popular. The motel, located at 477 Macon Highway, was owned and operated by Justus C. and Carol A. Harper. The buildings were razed several years ago, and the lot remains vacant.

King Cotton Motor Court was another early motel in Athens in the 1950s. The motel was built by James Hiram Hubert Jr. on the south side of West Broad Street in 1949—at what was then the Athens city limits. Hubert demolished the motel about 1961 and sold the property to investors. Present businesses at that approximate location include the Omni Club, a physical fitness center, at 2361 West Broad Street.

Seven

BRIDGES, TRAINS, AND AEROPLANES

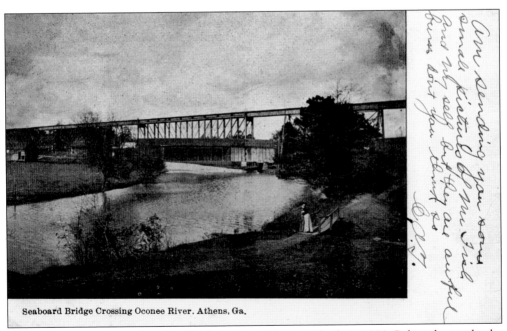

Seaboard Bridge Crossing Oconee River. Athens, Ga.

The Seaboard trestle crossing the North Oconee River was built in 1891. Below the trestle, the covered bridge spanning the river for automobile and horse-and-wagon traffic can be seen.

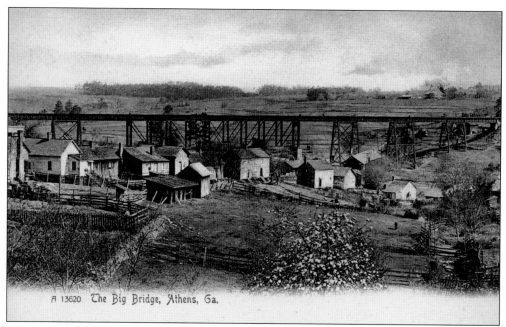

Another view of the trestle and bridge from a different angle also includes many frame houses that covered the area more than 100 years ago.

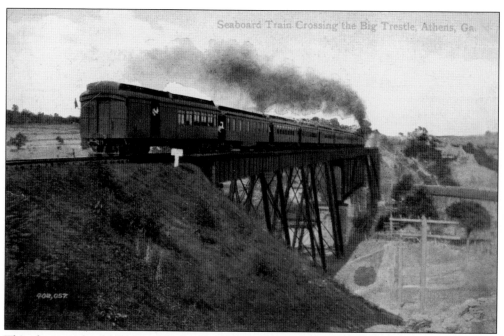

This photograph of the big trestle shows a long train crossing over the North Oconee River.

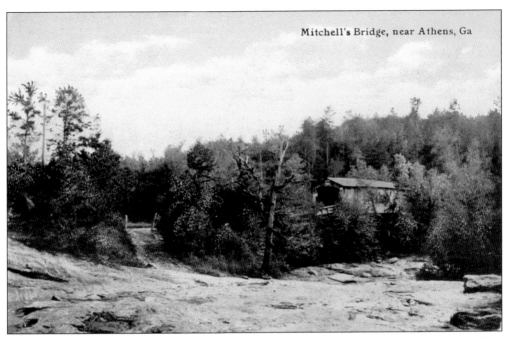

This covered bridge that crossed the Middle Oconee River on Mitchell Bridge Road was washed away during a flood in 1916.

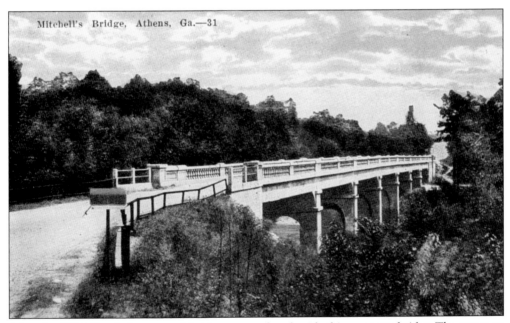

After the 1916 flood, the covered bridge was replaced with this concrete bridge. The concrete bridge was demolished in the 1980s during construction of the Athens bypass, and a new bridge, that is still used today, was built.

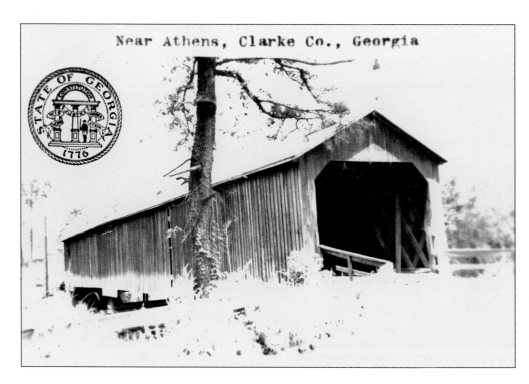

Near Athens, Clarke Co., Georgia

Athens's last covered bridge crossed the North Oconee River at Elm Street/Ruth Street. The bridge pictured here was built in 1908 to replace the former bridge that was washed away in a flood earlier that year. The bridge remained in service until 1965, when it was moved to Stone Mountain Memorial Park where it remains in use.

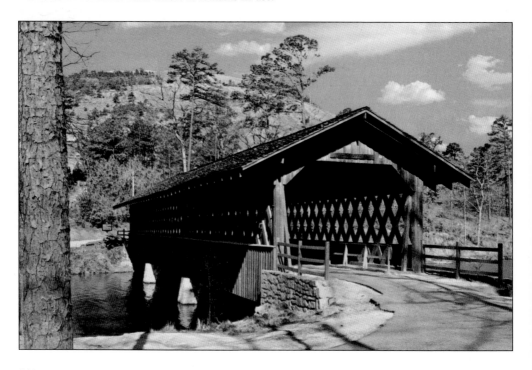

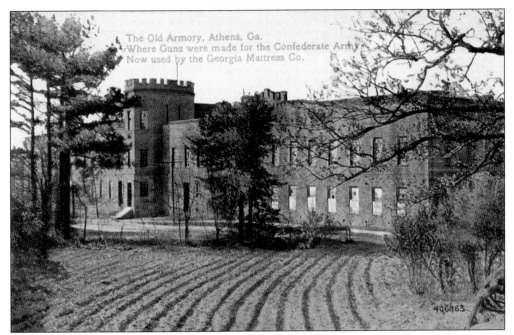

The Cook & Brother Armory was manufacturing guns for the Confederacy in New Orleans when the Yankees captured the city in 1862. Brothers Ferdinand W.C. Cook and Francis L. Cook escaped with their machinery and tools and relocated to Athens, where they erected a building and continued manufacturing Enfield–type carbines, musketoons, and rifles.

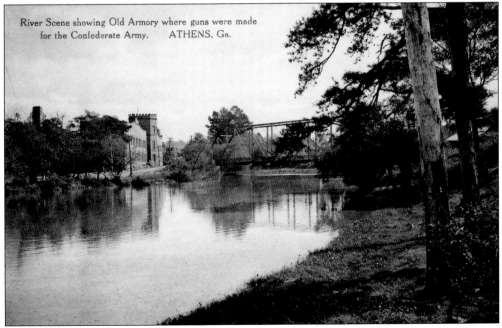

The Cook & Brother Armory was located across the Oconee River from the foot of Broad Street, where a covered bridge spanned the river. The bridge was washed away in the flood of late August 1908, which swept away most of the bridges in the Athens area. This steel bridge replaced it and remained in use until the 1980s, when it was replaced by the present concrete bridge.

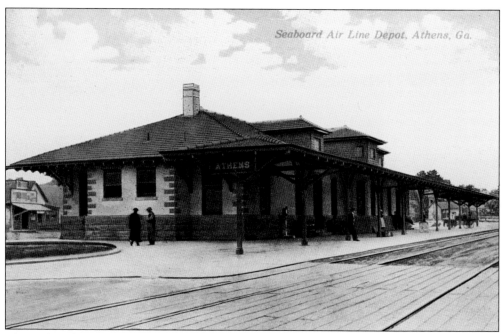

The Seaboard Air Line Depot on the north end of College Avenue was built in the 1890s. The term "Air Line" was used because railroad tracks often ran more or less in a straight line for many miles, and railroads advertised that they carried passengers and freight via the shortest and most direct routes. The building still stands, but passenger service to Athens was discontinued in the early 1970s.

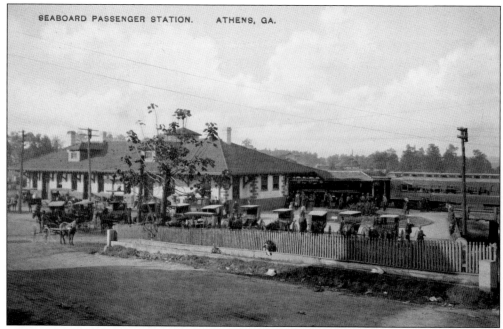

Above is a rear view of the Seaboard Depot around 1910. All the automobiles, buggies, and hacks delivering or waiting for passengers vividly illustrate the importance of railroad travel at the time.

The Dozier Land Company of Athens used this bifold postcard to attract potential bidders to a land auction to be held September 15, 1920. The postcard advertises "Free Balloon Ascension," declaring that a balloon was "going up about 1–2 miles" and that a man would leap out wearing a parachute. This was quite an exciting event for that time.

Bring the Children to See the Balloon go up. See the Parachute Leap.

Wednesday, Sept. 15th.

Free Balloon Ascension

Balloon contains 1056 of yds. cloth. Going up about 1-2 mile at the land sale.

Oconee Hill Cemetery was opened in 1856 on 17 acres on the west side of the North Oconee River. By the end of the century most of the lots had been sold, and an additional 90 acres were purchased on the other side of the river. This 16-by-100-foot steel bridge was completed in the summer of 1899 to provide access to the new land.

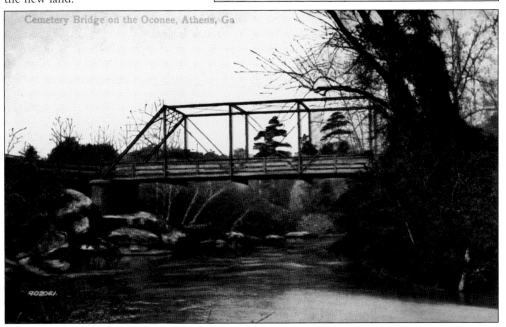

Cemetery Bridge on the Oconee, Athens, Ga

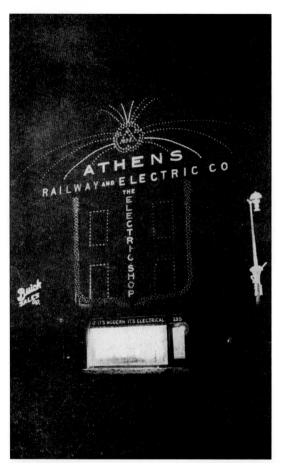

In 1885, a Texan named Snodgrass introduced the streetcar transportation system to Athens and ran mule-drawn streetcars along Broad Street, Clayton Street, Hancock Avenue, Milledge Avenue, Prince Avenue, and Pulaski Street. The system eventually became electrified and prospered as Athens Railway and Electric Company until automobiles became commonplace, driving it out of business. The last streetcar ran in Athens on March 31, 1930.

Executives with the Athens Electric Railway Company and the Southern Manufacturing Company congregate on the steps of the old Southern Mutual Building, where the offices of the companies were located in 1912. The Athens Electric Railway Company operated under various names during its lifetime and eventually became part of the Georgia Power Company.

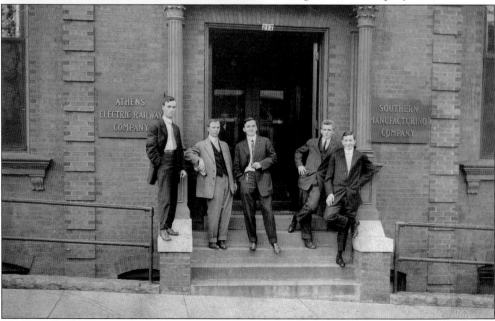

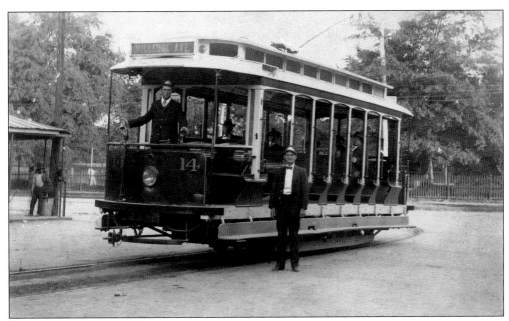

An open-sided summer streetcar stopped at the intersection of Broad Street and College Avenue around 1907. The conductor standing beside the streetcar is Cicero Williams Sr. Williams was born in Madison County, Georgia, in 1876. He moved to Athens in 1900 and worked as a conductor until streetcar service was terminated in Athens in 1930. He continued working for the Georgia Power Company until he retired in 1955. (Courtesy of Dale Autry and Juanita Williams Autry.)

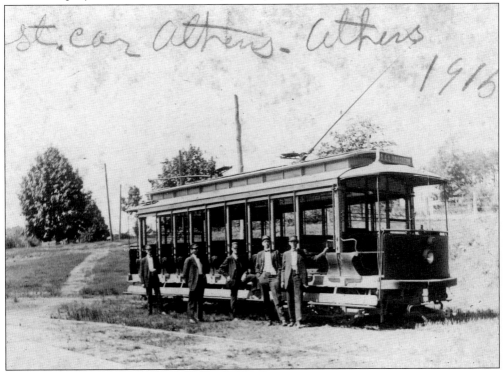

This is a group of conductors standing by an empty streetcar out of service.

A group of streetcar conductors pose in the carbarn on Boulevard in 1915. The man seated in the middle is George Marable, but the others are unidentified.

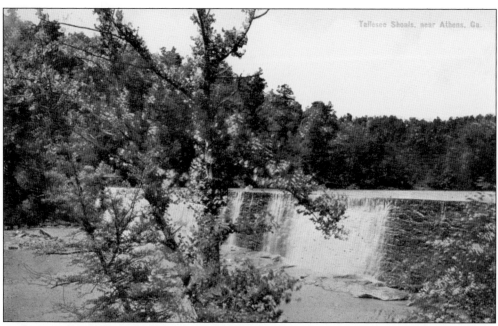

Power to operate the streetcar system was provided by generating plants at three sites on the Oconee River. The first was built in 1896 at Mitchell's Bridge. Tallassee Shoals Dam, shown here, was built a short distance upstream in 1900.

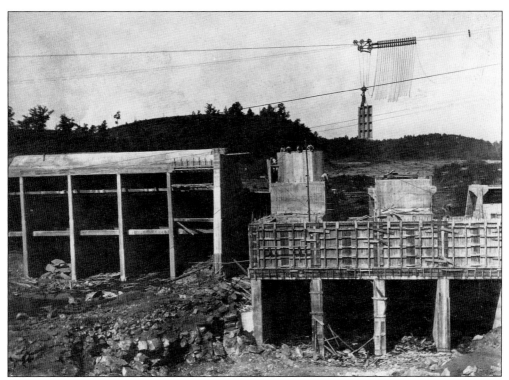

This is a rare real-photo postcard view of Barnett Shoals Dam and Power Station when it was under construction in 1910.

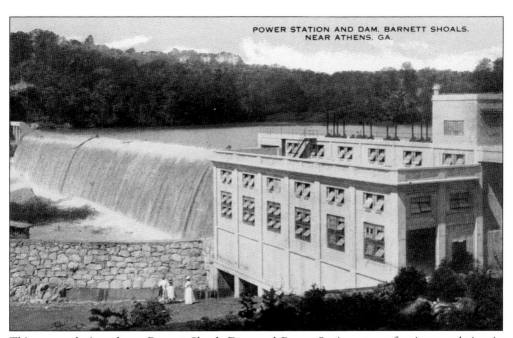

POWER STATION AND DAM, BARNETT SHOALS.
NEAR ATHENS, GA.

This postcard view shows Barnett Shoals Dam and Power Station soon after its completion in 1910. The scene looks very much the same today.

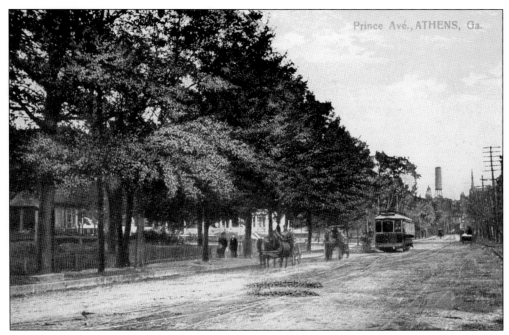

The tracks of the Athens streetcar system ran through the major streets downtown and extended out Prince Avenue all the way to the State Normal School, which was then beyond the city limits.

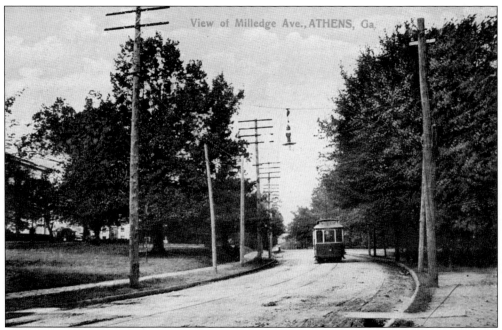

Milledge Avenue also was included in the streetcar route. Stops included St. Mary's Hospital, Lucy Cobb Institute, and Springdale Street, which led to the Cloverhurst Country Club.

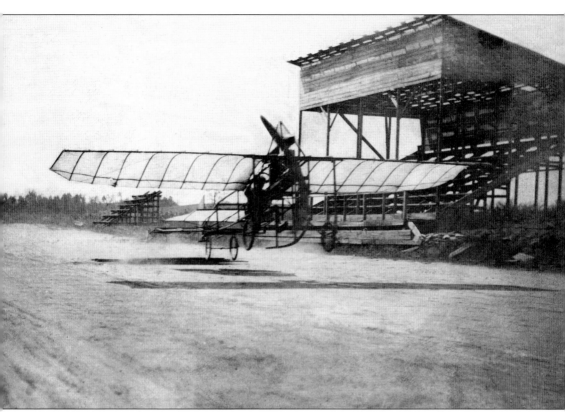

Benjamin Thomas Epps Sr. built the first airplane in Georgia in 1907, only four years after the Wright brothers' first flight in Kitty Hawk, North Carolina. Pictured here is a historic ascent in an airplane Epps built in 1910. The event took place on the racetrack of the Athens fairgrounds, the present location of UGA's Spec Towns Track and the Butts–Mehre Heritage Hall.

www.arcadiapublishing.com

Discover books about the town where you grew up, the cities where your friends and families live, the town where your parents met, or even that retirement spot you've been dreaming about. Our Web site provides history lovers with exclusive deals, advanced notification about new titles, e-mail alerts of author events, and much more.

MADE IN THE USA

Arcadia Publishing, the leading local history publisher in the United States, is committed to making history accessible and meaningful through publishing books that celebrate and preserve the heritage of America's people and places. Consistent with our mission to preserve history on a local level, this book was printed in South Carolina on American-made paper and manufactured entirely in the United States.

This book carries the accredited Forest Stewardship Council (FSC) label and is printed on 100 percent FSC-certified paper. Products carrying the FSC label are independently certified to assure consumers that they come from forests that are managed to meet the social, economic, and ecological needs of present and future generations.

FSC
Mixed Sources
Product group from well-managed
forests and other controlled sources

Cert no. SW-COC-001530
www.fsc.org
© 1996 Forest Stewardship Council

Find Your Place in History.